PIMLICO

635

PAINTING THE PAST

Sir Roy Strong was educated at the University of London, and the Warburg Institute. He joined the staff of the National Portrait Gallery in 1959 and became its Director from 1967 to 1973. He was Director of the Victoria & Albert Museum from 1974 to 1987 when he resigned to become a full-time writer, broadcaster and consultant. His books include *The Cult of Elizabeth, Gloriana, Henry Prince of Wales, The Story of Britain, The Spirit of Britain* and *Feast: A History of Grand Eating* (all available in Pimlico).

PAINTING THE PAST

The Victorian Painter and British History

———

ROY STRONG

PIMLICO

Published by Pimlico 2004

2 4 6 8 10 9 7 5 3 1

First published in Great Britain as
And When Did You Last See Your Father?
The Victorian Painter and British History by
Thames and Hudson 1978

Revised edition first published by
Pimlico 2004

Random House, 20 Vauxhall Bridge Road,
London SW1V 2SA

Random House Australia (Pty) Limited
20 Alfred Street, Milsons Point, Sydney,
New South Wales 2061, Australia

Random House New Zealand Limited
18 Poland Road, Glenfield,
Auckland 10, New Zealand

Random House (Pty) Limited
Endulini, 5A Jubilee Road, Parktown 2193, South Africa

The Random House Group Limited Reg. No. 954009
www.randomhouse.co.uk

A CIP catalogue record for this book
is available from the British Library

ISBN 1-8441-3083-5

Papers used by Random House are natural,
recyclable products made from wood grown in sustainable forests;
the manufacturing processes conform to the environmental
regulations of the country of origin

Typeset in Baskerville by Palimpsest Book Production, Polmont, Stirlingshire
Printed and bound in Great Britain by Biddles Ltd, King's Lynn

Contents

Preface

This book began as a series of lectures at the Pierpont Morgan Library as long ago as 1974. It then eventually appeared in 1978 under the title of *And When Did You Last See Your Father?* Both manifestations were too early and the book form was far from satisfactory. The present revised version is prompted by a comment in Peter Mandler's brilliant *History and National Life* (Profile Books, 2002): 'Roy Strong's *And When Did You Last See Your Father?* was another trailblazer that deserves a new edition and a new audience.' It has in fact taken almost thirty years for this subject to be taken seriously. Readers will find the earlier 1978 version more fully illustrated and slightly longer but it lacks the text-led focus of this edition. I am grateful to Pimlico for giving it a new lease of life.

ROY STRONG
January 2004

Part One

THE CENTURY OF HISTORY

To us, we will own, nothing is so interesting and delightful as to contemplate steps by which the England of Doomsday [*sic*] Book, the England of the Curfew and the Forest Laws, the England of the Crusaders, monks, schoolmen, astrologers, serfs, outlaws, became the England we know and love, the classic ground of liberty and philosophy, the school of all knowledge, the mart of all trade.

MACAULAY, 'Sir James Mackintosh', *Essays*

For the history of our country during the last hundred and sixty years is eminently the history of physical, of moral, and of intellectual improvement.

MACAULAY, *The History of England* (1848)

A Victorian Vision

The Victorian vision of the British past evokes a glorious panorama within the mind: Boadicea rallying the Ancient British against the autocratic forces of Rome, valiant Anglo-Saxons repelling Danish invaders from the shores of Britain, King John signing the Great Charter, the foundation of our liberties, innocent child Princes murdered in the Tower, beautiful tragic Queens making their way towards the scaffold, heroic Cavaliers on the battlefield, the Jacobites fighting for a lost cause. The figures we all know so well rise from our past: the Saxon hero-king Alfred, the valiant crusader Richard I, the wicked hunchback Richard III, bluff King Hal, magnificent Elizabeth, innocent Jane Grey, doomed Mary of Scotland, sad-faced Charles I and stern-countenanced Cromwell, the Merry Monarch and Bonnie Prince Charlie. They grip the imagination as history fuses with romance. In the old-fashioned way of teaching history, which still lingered a little when I was a child during the Second World War, history began with these heroes and heroines, stories and anecdotes. But it also began with pictures – not those dry-as-dust reproductions of old portraits and tombs, dead artefacts now in museums and ancient buildings, but something much more powerful, images which swung wide a window into the past, made it human, living and real. Millais's *Boyhood of Raleigh* (1870), in which the future poet and explorer listens to an old sailor telling of the voyages of his youth, made the Elizabethan age of

discovery thrilling to me. Delaroche's picture (1830) of the young Edward V and his brother, the little Princes in the Tower, chilled the spine in anticipation of their imminent and horrible end. Frederick Goodall's *An Episode of the Happier Days of Charles I* (1853), in which the tragic King, his beautiful Queen and even more adorable children sail down-river on a summer's day, made me a Cavalier for life.

Until three generations ago, these pictures were part of the visual experience of every child brought up on British history. Now they have long been banished from school textbooks as inaccurate, misleading and unauthentic. The best-selling prints made after them that once adorned the walls of Victorian and Edwardian nurseries and schoolrooms have been taken down and relegated to the attic. Worst of all, art historians have come to regard these creations as dreadful aberrations which ought never to have happened,[1] and in public museums and galleries most surviving examples have been consigned to the stores, rolled up or even, in some instances, deliberately destroyed as worthless rubbish. An intensely creative part of British nineteenth-century painting has been dismissed as a dead end. But was it?

The studies which form the basis of this book began for me almost as a personal indulgence. I happen to like this sort of painting. On the lowest level, there is something incredible about an artist's ability to transport the onlooker back in time, give him glimpses of his heroes and heroines, recapture the modes and manners of distant ages. This may not, of course, be art, but it was something which obsessed nineteenth-century painters and which they were extremely good at doing. Again, one wants to know why. What made them interested in some periods and not in others? What was the relationship between contemporary history painting and history writing? What was the impact of Sir Walter Scott and his successors as exponents of the historical novel? What was the connection between the rise of antiquarianism and the increasing pictorial accuracy of

4

1. Sir John Everett Millais, *The Boyhood of Raleigh* (1870).

the painters of the past? What, overall, was the role of this national historic mythology in the make-up of the Victorian mind and imagination? These questions have to be answered before one can even understand, let alone pass judgment. Some readers may wonder why I choose to isolate this particular Victorian vision as against any other – their view of classical antiquity, for example, or of English literature, or even of events within living memory – but I believe that if we are ever to understand the motivation of art in the Victorian age we must concentrate on one aspect and analyse its iconography with a seriousness which until recently has been totally denied to it. This is what this book sets out to do: to tackle just one thread of image-making, but that perhaps the most nostalgic and potent thread of all.

The painting of Victorian England is for most of us unthinkable

without the familiar milestones created by the art historians of the last generation, that generation which rediscovered the art of the nineteenth century. Guided by the Berensonian belief that art is really little more than the evolution of style, we now think in set terms of the Pre-Raphaelites, of Morris and his circle, of the resurrected personalities of Millais, Rossetti, Burne-Jones, Ford Madox Brown or Lord Leighton. These are the safe loadstones of the historian, and beyond them there exists a kind of condescension to the other figures of Victorian painting. We cultivate third-rate Pre-Raphaelite artists because we approve of their milieu – a world of images echoing the obsession of our own painters with private as against public mythologies – but we ignore the sheer quality and brilliance of C. W. Cope's or E. M. Ward's great historical set pieces in the Houses of Parliament. Indeed, I would go further and say that the technique of many of the figures we now place in the top rank of Victorian painting is often lax and feeble in comparison with that of several of the artists whose totally neglected works I shall go on to discuss.

The present pantheon of Victorian art has been created largely through literature. Like the Bloomsbury circle, which again has given prominence to third-rate painters, Rossetti and Morris are known to us as writers and even more as people who led romantic and often highly unconventional private lives. I believe this approach to Victorian painting, with its heavy bias towards the literary and biographical, to be a wrong one. Through it we have succeeded in creating a history of Victorian art as selective and biased as the Victorians' own attitudes towards their own past. We can no longer afford to accept this distortion. The serious consideration of the paintings dealt with in this book may not be a welcome innovation, particularly to those who still regard the subject-matter of Victorian painting as something for amusement but certainly not for analysis in depth. I feel, on the contrary, that these pictures should leave us with a sense of awe and wonder. There is something deeply moving

and courageous about the confidence with which they evoke the visible past. It starts from a premise of self-possession and of security within the present, totally unknown to us, which enabled the painter's brush for a brief period to defy time as it moved triumphantly through it.

History Writing and History Painting

The roots of these childhood favourites lie, of course, in the eighteenth century. The initial desire to paint scenes from British history reflected not only a change in attitude to our national past, but also the alignment, in the second half of the century, of the aspirations of British artists with the rise of antiquarian studies. As a consequence paintings dealing with British history can be fairly conveniently categorized into three main groups which will give us a handy framework in which to move. The first I would define as 'Gothick Picturesque', by which I mean the earliest essays using noble and uplifting incidents from British history by artists such as Robert Edge Pine, John Hamilton Mortimer, Francis Wheatley or Angelica Kauffmann. As a phase it began after 1760, reached its apogee on the walls of the Royal Academy in the 1770s and 1780s, and came to a close in 1806 with the end of Robert Bowyer's Historic Gallery, which had been a major source of patronage in the 1790s through the commissioning of paintings for an illustrated edition of David Hume's *History of England*. Out of this sprang a second phase, which I have designated 'Artist-Antiquarian'. This used the same mind-improving subject-matter from the past, but applied to it the discoveries of the antiquarians, thereby lifting its productions on to a new level of pictorial accuracy. Artist-Antiquarian had its beginnings in the achievements of Gavin Hamilton, Benjamin West and John Singleton Copley, reached a new level of historical veracity in France

in the work of Paul Delaroche and found in Victorian England its prime exponents in artists such as E. M. Ward and C. W. Cope in the 1850s and 1860s. Eight years after the demise of the Bowyer Gallery came the publication of Sir Walter Scott's *Waverley*, an event which led directly to the development of a third format, which I have called 'Intimate Romantic' – that is, paintings which take as their subject-matter personal, domestic glimpses of earlier ages, the great of the past caught informally or even, beyond this, the past painted purely for itself as an enchanted idyll. Through this the past was able to inspire the brushes not only of history painters but also of the exponents of genre.

Origins: British History, George Vertue and William Kent

The Gothick Picturesque phase was born of two movements in eighteenth-century England, the revival of history writing and the desire of British artists to fulfil academic theories on the primacy of history painting over any other genre. With regard to the first, it was not in fact until the third quarter of the century that the writing of history revived in England; when it did, it began to resemble history as we know it today rather than the chronicle or politico-religious polemic of the previous century.[1] 'History is philosophy teaching by examples,' wrote the statesman, Henry Saint-John, Viscount Bolingbroke, pioneering this new attitude in his *Letters on the Study and Use of History* (1735).[2] Through the study of history, and in particular of modern history from the fifteenth century onwards, man was able to gain not only ethical guidance but knowledge and judgment upon which he could act both immediately and in the future. This switch of emphasis was immensely important for shifting the focus of historical subject-matter away from classical antiquity. The great historians, David Hume, William Robertson and Edward Gibbon, represented the climax of history

9

writing in eighteenth-century Britain; its masterpiece was Gibbon's *Decline and Fall of the Roman Empire* (1776). All three authors saw history as a search for truth, a pursuit of underlying political and philo-sophical motives. All three too shared an Augustan condescension to the past. History was fascinating for its lessons to the present, but never for itself alone. The subject-matter of Gibbon has no impor-tance for our national saga. From the point of view of the devel-opment of scenes from British history, the two key books drawn upon by artists for subject-matter were the histories written by a Frenchman, Paul de Rapin-Thoyras, and by David Hume.

Rapin lived for a time in England, but wrote his history of the country down to the reign of William III after he had left and taken up residence in Germany and Holland. This was published in ten volumes between 1723 and 1727 and translated into English in 1726–31, and, until superseded in 1754 by Hume's *History*, was regarded as the standard narrative of England from the remotest times. Rapin's central thesis was that the English monarchy had always been a limited one and that the liberty of the subject had only from time to time been violated by tyrannical kings. The most important edition of his work was that of 1743–7 illustrated by Charles Grignion, Hubert François Gravelot, both exponents of the rococo, and the artist and antiquary George Vertue, who were commissioned to adorn the seven folio volumes with maps, genealogical tables and 'the Heads and Monuments of the Kings'. In these engravings, the renaissance in history writing joins hands with the revival of anti-quarianism. As I will demonstrate in the next chapter, the rise of antiquarian studies in eighteenth-century England had a profound effect on history painting. Writers of history gave painters subjects to depict, but antiquarians gave them the means whereby to carry out such re-creations. Vertue's portraits are thoroughly researched from tombs or 'antient pictures', even if in the process they are rein-terpreted in a later stylistic idiom. Sometimes, too, if we examine his rococo borders we find he has inset scenes from the lives of the

2. George Vertue, Imaginary scene of the abdication of Richard II. Detail of engraving from Paul de Rapin-Thoyras, *The History of England* (1726–31).

persons depicted. Beneath Richard II's portrait, for instance, based on the famous full-length in Westminster Abbey, he has drawn an imaginary scene of the King's abdication. In these insets Vertue, as a trained antiquary, shows a remarkable grasp of period reconstruction, far in advance of the history painters of the Gothick Picturesque. The main sections of Rapin's *History of England* are also preceded by small headpieces in which certain scenes from British history – seeds of the Victorian vision, destined to have a long and extraordinary life – made their artistic début: Rowena and Vortigern, for instance, the signing of Magna Carta or the trial of Queen Katherine of Aragon.

If Vertue played a crucial role in translating history and antiquarianism into art, so also did the seminal architect, painter and garden designer, William Kent.[3] With Kent's work we enter into the intellectual circle which centred on George II's Queen, Caroline, 'for Love of Arts and Piety Renown'd'. The Queen was primarily interested in religion, philosophy and letters, and the visual arts

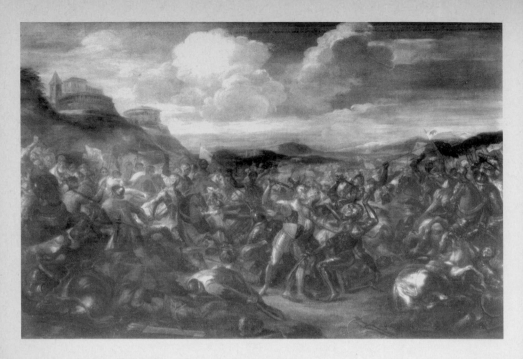

3. William Kent, *The Battle of Agincourt* (*c.* 1729–30).

were used by her to give tangible form to her intellectual attitudes
and cults. Kent was ideal for her because his genius lay in being
able to translate into visual terms the philosophical and aesthetic
ideas of others. For Caroline he executed three buildings in her
garden at Richmond Palace, a thatched cottage called Merlin's
Cave, a hermitage or grotto in the Gothick style and a third build-
ing which was to contain busts of all the kings of England since
William I. The Queen's interest in the British past found expres-
sion also in the decoration of her dressing-room at Kensington
Palace. Here she framed and hung the celebrated Holbein draw-
ings of members of the court of Henry VIII which she had redis-
covered at the back of a bureau; here, too, were gathered together
for the first time all the earliest portraits of monarchs in the royal
collection. She even purchased such portraits.[4] To these she added
a set of three pictures commissioned from Kent in 1729–30, depict-
ing scenes in the life of Henry V: the Battle of Agincourt, the meeting

of the victorious English King and the Queen of France and, finally, the King's marriage to the French Princess, Catherine.[5] Painted a year before Kent's first essay in the Gothick style, the rebuilt Clock Court Gatehouse at Hampton Court, they represent the first serious attempt to depict accurately scenes from medieval history. His departure from the treatment of such themes by painters within the

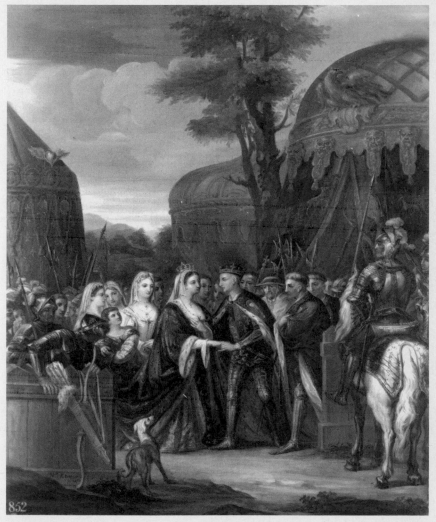

4. William Kent, *The Meeting between Henry V and the Queen of France* (1729–30).

13

5. Unknown artist,
Henry V.

still vigorous baroque tradition of Antonio Verrio and Sir John
Thornhill is so deliberate that, although feeble as pictures, they are
manifestos as to the correct treatment of historical subjects. On a
first glance it would, of course, be difficult to guess that this was
what he was aiming at. In *The Battle of Agincourt* the landscape is
reminiscent of Claude Lorraine and the combatants are arrayed in
a hopeless confusion of inaccurate armour. In the middle we can
identify Henry V only because he has the arms of England blazoned
on his armour and he vanquishes an opponent, possibly meant for
the Duke of Alençon, who wears the fleur-de-lis. Nor is there much
advance in the canvas of the meeting of Henry with the Queen of
France. Once more we have an odd assortment of armour, the
ladies attired in nondescript robes and the action backed by exotic

tents. But, in spite of these vagaries, the King's head is based on one of the two portraits we know Caroline owned.[6] This in itself is significant. The urge to research the subject and integrate such discoveries into the composition was there. And this was new. Kent was aware that the Middle Ages were different, but he had not as yet the means to put together just how different. Crude and wooden though these canvases are, they foretell all that was to come for almost the next two hundred years.

Gothick Picturesque

Vertue and Kent were therefore central figures in the propagation of the idea of the British past as heroic. They were also artists turned antiquaries; they knew that the past had to be researched before it could be reproduced. In the case of the mainstream of painters I have categorized as exponents of the Gothick Picturesque, this approach to the British past was purely incidental. But, at this juncture, it is to these and to the proliferation of historical subjects which their work brought about that we must now turn our attention.

Late-eighteenth-century painters were primarily drawn to the British past because it provided a whole new range of subjects – national rather than classical – fit for those aspiring to the genre of history. Inheriting the primacy of history painting in the hierarchy of genres from the French Academy of the previous century, all theorists from Jonathan Richardson at the opening of the eighteenth century down to John Opie, James Barry and Benjamin Robert Haydon at the close of it adhered to this fundamental tenet. In heroic action and perfect physical form man could see his own ethical and corporeal potential. Such an art called for scenes of bravery, self-sacrifice, noble love and triumphant faith. The principles which led to this search for a new, meaningful nationalistic iconography are

admirably summed up in a letter written by the American painter
Benjamin West to his compatriot Charles Willson Peale in 1809:

> . . . the art of painting has powers to dignify man, by trans-
> mitting to posterity his noble actions, and his mental powers,
> to be viewed in those invaluable lessons of religion, love of
> country, and morality; such subjects are worthy of the pencil,
> they are worthy of being placed in view as the most instruc-
> tive records to a rising generation.[7]

Such a theoretical position was to dominate British art and artists
for a century and provide the aesthetic basis for their re-creations
of the past. Its culmination was the mid-Victorian cult of High Art
– the idea that the greatest art could only be expressed in the form
of monumental commissions – which reached fruition in the
competitions for the decoration of the new Houses of Parliament.

History painting really began in 1760 with the first exhibition of
the Society of Artists, an annual event which led to the creation of
the Royal Academy in 1768. Both gave British artists for the first
time the opportunity of exhibiting in public, and the importance
attached to history painting was emphasized by the two premiums,
one of a hundred guineas and one of fifty, offered by the Society
each year for subjects taken from English history. In 1760 the first
premium was won by Robert Edge Pine for his canvas *The Surrender
of Calais to Edward III*. Pine won the prize again three years later for
his *Canute reproving his Courtiers for their Impious Flattery*, which Walpole
described as 'much the best'.[8] Both were on the subject of mon-
archy, the first celebrating the King's mercy on the intercession by
his Queen, Philippa, for the lives of the burghers of Calais, the
second Canute's reproof to his courtiers for their flattery in suggest-
ing that he could at will command the tide, asserting that the essence
of monarchy lay in the attribute of humility. John Sunderland has
pointed out Pine's sympathy with anti-monarchical currents in

6. Robert Edge Pine, *Earl Warren making Reply to the Writ commonly called 'Quo Warranto' in the Reign of Edward I, 1278* (1771).

sixties' politics, and suggested that the subjects were chosen to draw a political moral against current reassertions of the royal prerogative by George III.[9] This may certainly be true, but they could as easily be read the other way, as commemorations of royal virtues. The ambiguity of interpretation was no doubt deliberate. If, for instance, the subject of the burghers of Calais was generally considered to be anti-monarchical, it would hardly have been included by the Tory-oriented West in the series on the wars of Edward III painted in the eighties for George III's Audience Chamber at Windsor Castle.

The *Canute* painting was exhibited again by Pine in 1768, and in 1771 came his last picture drawn from British history, an unfinished canvas drawn from an incident in Rapin, *Earl Warren making Reply*

17

to the Writ commonly called 'Quo Warranto' in the Reign of Edward I, 1278.
By that year Pine was deeply engaged in the cause of the political
demagogue, John Wilkes, who was jailed for attacking the king's first
minister, Lord Bute, so the choice of a subject which dealt with the
infringement of civil liberties in late-thirteenth-century England was
clearly intended as an outspoken criticism of royal pretensions.
Edward I had commissioned an inquiry into all encroachments on
the royal demesnes, but his commissioners went too far and began
to question titles of estates which had passed from father to son for
several generations. Earl Warren, asked to show his titles, drew a
rusty sword from its scabbard and said: 'This is the instrument by
which my Ancestors gained their Estate, and by this I will keep it as
long as I live.'[10] This being reported to Edward I, he prudently
annulled the commission. Pine has grandly conceived the composi-
tion in terms of a Judgment of Solomon, Esther before Ahasuerus
or Christ before Pilate, but it cannot be said to have much merit as
a painting. Pine did not return to history again, but turned to illus-
trating Shakespeare, again without success, and finally left England
to seek his fortunes in the newly formed republic of the United
States.[11]

The second prize in 1763 went to Pine's pupil, John Hamilton
Mortimer, then aged twenty-two and notorious for his passion for
bizarre subject-matter. The picture was *Edward the Confessor stripping
his Mother of her Effects.*[12] 'Edward's Figure', Walpole wrote, 'strong
and bold, but not characteristic and too large in proportion to the
rest, most of which is bad.'[13] The allusions are obscure, but again,
as in the case of Pine's *Quo Warranto*, the general theme seems to
be British liberties, the accession of the saintly Edward the Confessor
being billed as the return of the freedom-loving Anglo-Saxon mon-
archy in place of the hegemony of the Danes. Edward's mother,
Emma, was Norman by birth and had married successively Ethelred
the Unready and the Danish Canute. She, therefore, with her pref-
erence for her second husband and her children by him, represents

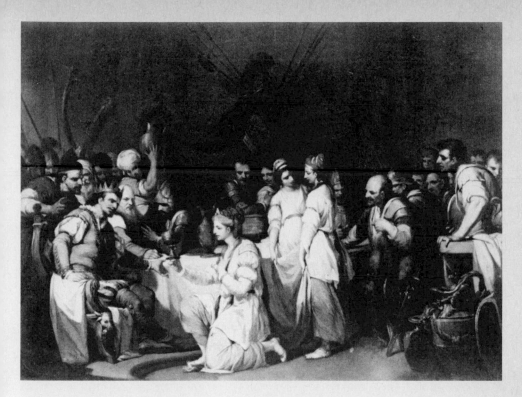

7. John Hamilton Mortimer, *Vortigern and Rowena* (*c.* 1776).

the Danish interest, whereas Edward, her son by her first marriage, stands for the Anglo-Saxon.[14]

The year after, Mortimer took the first prize with his *St Paul preaching to the Britons*, an excursion into the mythology of the Church of England. Mortimer did not return for another thirteen years to British history, and then, at the age of thirty-six, he painted three pictures: *King John delivering Magna Carta to the Barons* (*c.* 1776), *Vortigern and Rowena* (*c.* 1776) and *The Battle of Agincourt* (*c.* 1776). The last, a heroic battle scene, needs no explanation. Magna Carta, of course, symbolizes the birth of representative government, a reassertion of Anglo-Saxon liberties against the bondage and slavery of feudalism: 'And thus', wrote Hume, 'the establishment of the great charter . . . became a kind of epoch in the constitution.'[15] From whatever political stance it was viewed, it was a moment to be celebrated, and the pictorial apotheosis of the British Constitution, which was

to reach its climax a century later, began in earnest with this canvas by Mortimer.

Vortigern and Rowena, however, take us on a more exotic voyage into the past. This was a subject essayed by Henry Fuseli in 1769 and by Angelica Kauffmann the year after.[16] Mortimer's picture, like those of Pine, was a monarchical morality. Vortigern was the British Prince who had invited the Saxons, headed by Hengist and Horsa, into the country in order to defend the Britons against the ravages of the Picts and Scots. Subsequently, however, Hengist used the charms of his niece Rowena to further his ambitions, and this is the scene Mortimer depicts. At a great entertainment given by Hengist, Rowena was bidden by him to take their royal guest a cup of wine. Vortigern was so overcome by her loveliness that he refused to drink from the cup until Rowena had touched it with her lips. This she did, after which he drank and kissed her passionately. Although already married, Vortigern divorced his wife and married Rowena, ceding Kent to Hengist in return. So he began on the downward path which led to his deposition and banishment to a life of solitude as an object of contempt.[17]

Pine and Mortimer had set a pattern, choosing subjects which were to be repeated time without number in the next hundred years. That they were influenced by scenes depicted in Rapin's *History* and other illustrated books cannot be doubted. From about 1770 onwards there appeared a whole succession of histories which, however wildly inaccurate and feeble their illustrations, must have done much to accustom the public to the idea of 'seeing' the past.[18] To those essaying the Grand Manner in painting, the subject-matter thus disseminated must indeed have given material for thought: 'King Edmund the First assassinated by Leolf the Robber, while celebrating the Feast of St Augustine in the Church of Puckle, Gloucestershire' or 'Judge Jefferies in the disguise of a sailor seized at Wapping' evoke the ambience of the penny dreadful rather than the ennobling pages of our national history. Scenes from British history, therefore, prolif-

erated greatly during the last thirty years of the eighteenth century in the work of Mather Brown, Richard Westall, Thomas Stothard, John Downman, James Northcote and John Opie, who systematically excavated the past for scenes of heroism and patriotic self-sacrifice, one which was fed at the turn of the century by the war with Napoleon which was to stretch over more than two decades.

The painting of such canvases was encouraged in the final years of the century by two major schemes of patronage, the first Alderman Boydell's Shakespeare Gallery, inaugurated in 1785 with the explicit purpose of aiding the formation of a British school of history painting, and the second, much less well known or investigated, Robert Bowyer's Historic Gallery in Pall Mall, a collection of paintings of scenes from British history commissioned for a large folio edition of Hume issued between 1793 and 1806. The Boydell scheme, which belongs to another iconographic stream, that of illustrations to literature, has been studied in some detail by T. S. R. Boase, W. Moelwyn Merchant and Winifred Friedman.[19] Bowyer, however, remains to be examined in depth. Robert Bowyer was miniature painter to Queen Charlotte and issued his prospectus for a 'superbly embellished' edition of Hume in 1792, the year war broke out with France. By 1806 five huge folios had appeared taking the story to 1688, after which the whole scheme collapsed with a rumoured loss of £30,000. More than a hundred pictures were painted for him by artists who included Gavin Hamilton, Henry Fuseli, James Northcote, Robert Smirke, Benjamin West, Henry Tresham, Richard Westall, Francis Wheatley, John Francis Rigaud, Henry Singleton, Philippe de Loutherbourg and Maria Cosway. Bowyer's work was designed 'to raise the passions, to fire the mind with emulation of heroic deeds, or to inspire it with detestation of criminal deeds'. Although influenced in its subject-matter by Rapin, the book in its turn contained a repertory of scenes decisive for the canon of the Victorian vision: Queen Margaret of Anjou and the robber, Lady Elizabeth Grey entreating Edward IV to protect her children, Lady Jane Grey's

reluctance to accept the crown and her execution, Mary Queen of Scots' escape from Lochleven and execution, and Lord William Russell's farewell to his wife, were to recur again and again on the walls of the Royal Academy.[20] As a group, they were definitive for what I have categorized as the Gothick Picturesque view of the British past. They reveal in addition the ambitions of artists whom we now think of in quite another context. Who would ever, for instance, associate Francis Wheatley, immortalized by his sentimental prints of the 'Cries of London', with canvases on the subjects of *Alfred in the House of the Neatherd* (1792) or *The Death of Richard II* (1795)? It is irresistible to quote a contemporary reaction to the latter: 'If Mr Wheatley ever prays, we hope he will repeat in the words of the Litany "to be defended from all privy conspiracy and rebellion, from battle and murder, and from sudden death".'[21]

An analysis of subjects from both Bowyer's Historic Gallery and the Royal Academy reflects an overwhelming preoccupation with the Middle Ages; scenes from Tudor and Stuart history run neck and neck in second place, while incursions into remoter antiquity in the form of the heroic Ancient Britons, Boadicea and Caractacus, are fewer and represent little more than an attempt to find purely classical Roman scenes from British history. The choice and the repetitious nature of the subject-matter are not without interest. Three incidents in British history positively obsessed the late-eighteenth-century artist: King Edward IV's encounter with Lady Elizabeth Grey, incidents connected with the story and the eventual death of the Princes in the Tower, Edward V and his brother the Duke of York (also, of course, relevant for those whose approach to history was through literature), and finally scenes from the life and, more particularly, the death of Mary Queen of Scots. To gain some measure of the scale of these obsessions it is useful to list what was painted. Samuel Wale (1760 and 1763), Angelica Kauffmann (1776), John Francis Rigaud (1796), John Downman (1797) and John Opie (1798) all depicted the encounter of the Yorkist King Edward

IV and the widow of Sir John Grey. David Allan (1791), Gavin Hamilton (1776), John Howes (1786), John Opie (1787), Richard Westall (1789 and 1791), John Francis Rigaud (1791 and 1792), John Graham (1787, 1788 and 1792), Samuel Medley (1793) and Mather Brown (1788) tackled moments in the life of Mary Queen of Scots, and Joseph Highmore (1769), Samuel Wale (1769 and 1775), James Northcote (1786) and Henry Singleton (1797) depicted incidents leading up to and including the murder of the Princes in the Tower. In addition, the celebrated intercession of Edward III's Queen, Philippa, for the lives of the burghers of Calais was painted by Robert Edge Pine (1760), Benjamin West (1788) and Richard Westall (1790).

Even if the quality of these paintings, where they are still traceable, is in the main depressing, the explosion in subject-matter was extraordinary. Within a wider context, it was paralleled from 1760 onwards by similar developments in other fields: the discovery of new literary sources for art (Milton, Shakespeare, Spenser, Dante, medieval legends and romances); a more intensive study of the phenomena of nature, whether expressed in Stubbs's analytical drawings of the horse or William Hodges's records of Cook's voyages; new emphases within religious imagery on the Old Testament and the Apocalypse; a realization of the actuality of the world of classical antiquity as a result of the archaeological finds of Herculaneum and Pompeii; a curiosity regarding every aspect of the present, whether in the form of great events or humble occupations; and over all, animating this furore of originality, a release of the emotions, made possible by the empirical philosophy of Locke and his successors, leading to an examination of every facet of the human psychology. The national past is just one idiosyncratic thread in this pattern of ideas and obsessions which led up to the explosion of the imagination we know as the Romantic Movement.[22]

It would not add greatly to our understanding of this phenomenon if we examined each historical subject in detail; I propose

therefore to take one subject only as an instance of the method and approach of the Gothick Picturesque School as a whole. Edward IV's encounter with Lady Elizabeth Grey is a particularly well documented example because so many of the pictures are still identifiable. Incorporated into the standard narrative histories of both Rapin and Hume is the story of the Yorkist King Edward IV's passion for Elizabeth Woodville, the widow of Sir John Grey, a lady 'remarkable for the grace and beauty of her person, as well as for other amiable accomplishments'. Here is an abridgement of Hume's account of their meeting:

> The king came accidentally to the house after a hunting party . . . and as the occasion seemed favourable for obtaining some grace from this gallant monarch, the young widow flung herself at his feet, and with many tears entreated him to take pity on her impoverished and distressed children. The sight of so much beauty in affliction strongly affected the amorous Edward; love stole insensibly into his heart under the guise of compassion . . . He raised her from the ground with assurances of favour . . . and he was soon reduced, in his turn, to the posture and style of a supplicant at the feet of Elizabeth.[23]

The widow, of course, honourably resisted his advances, so that the King finally asked her to marry him. It was a perfect subject for the close of the eighteenth century, combining a scene fit for a Gothick romance by Mrs Radcliffe with visual spectacle akin to the family of Darius imploring mercy of Alexander.

John Francis Rigaud, in 1796, set the scene in a Strawberry Hill Gothick hall, with Lady Elizabeth and her children flinging themselves at the feet of Edward IV – a dramatic tableau conceived almost wholly in terms of decoration. A year later John Downman, heavily influenced by Rigaud, delineated exactly the same type of interior: within it the King clutches his heart, while Lady Elizabeth,

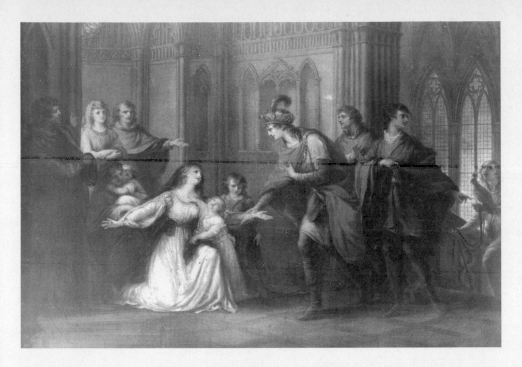

8. and 9. The Gothick Picturesque approach to history: (*above*) John Francis Rigaud, *Lady Elizabeth Grey petitioning King Edward IV for her Husband's Lands* (1796); (*below*) John Downman, *Edward IV on a Visit to the Duchess of Bedford, is enamoured of Lady Elizabeth Grey* (1797).

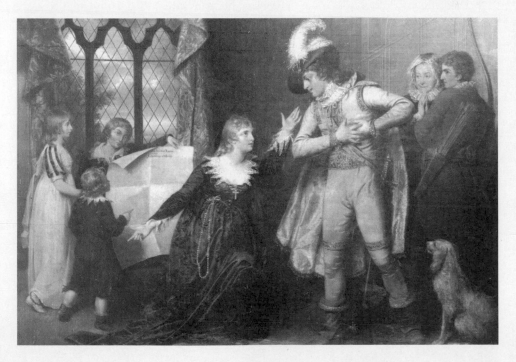

on her knees, gestures frantically both towards him and to her children, who literally hold up her petition for the restoration of her husband's lands. Anything less like life in England in the last quarter of the fifteenth century would be difficult to compile. These pictures are the essence of the Gothick Picturesque. There is no attempt at correct historic portraiture, dress or architectural setting. A portrait of Edward IV was available in the illustrated Rapin, but no one even bothered to look. Any feeling for the Middle Ages demonstrated here belongs firmly to the world of Strawberry Hill and the vagaries of historical dress as introduced by David Garrick to the stage. When the scene reappeared on the walls of the Royal Academy a year later in John Opie's version (1798) for Bowyer's Historic Gallery, a chiaroscuro treatment heavily indebted to the Bolognese School, there was still no development in approach.[24] This may be a better picture, but Elizabeth could literally be any aristocratic lady of the 1790s in a state of distress. Indeed, she looks more like Marie Antoinette than Elizabeth Woodville. Nor, over a decade later, did that prolific illustrator of the British past, Robert Smirke, show any advance. He drew little more than a fancy-dress tableau suitable for any Gothick novel of the day. The important point is this: if any of these four artists had wanted to recreate the past more accurately, he could easily have done so. Benjamin West and John Singleton Copley alone pursued the incipient antiquarianism of Vertue and Kent in the late eighteenth century, and it was from them that the new style, which I call Artist-Antiquarian, flowed down into the Victorian age. Exponents of the Gothick Picturesque ignored the antiquarian implications of their subject-matter, and cheerfully indulged in a repertory of pasteboard architecture across which they swagged draperies to conceal their lack of knowledge of the structure of the historical styles. They had no clue as to accuracy in dress, which rarely rises above an orgy of ecclesiastical vestments, slashed doublets, plumed hats, frills, ruffs and

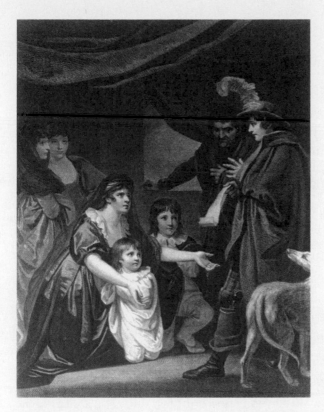

10. After John Opie,
*Lady Elizabeth Grey
entreating Edward IV
to protect her Children*
(1798).

armour thrown together to serve for virtually any period from the
Anglo-Saxons down to Elizabeth Tudor. This Gothick Picturesque
evocation of the British past was as charming and as insubstan-
tial as a wood and pasteboard garden gazebo by Batty Langley.
By the close of the Napoleonic Wars it had vanished, vanquished
by the dual forces of the serious antiquarian standards being intro-
duced to history painting and the ethos of romanticism epitomized
by Scott and the historical novel.

The Creators of the Artist-Antiquarian: Hamilton, West and Copley

If the subject-matter of the Gothick Picturesque artists was a vivid reflection of one aspect of the revolutionary currents in British eighteenth-century painting, the application to these subjects of standards of antiquarian accuracy represented another. This search belonged to a wider canvas, of which scenes from British history formed only a part. The investigation and reconstruction of the past was one facet of the movement, stemming from the Enlightenment, which animated the whole realm of knowledge and experience in late-eighteenth-century Britain. And it is crucial to grasp that those artists who were pioneers in incorporating the latest archaeological discoveries into their paintings of the classical world were the very same who pioneered historical accuracy in their evocations of the medieval, post-medieval and modern periods.

First amongst these was Scottish painter and archaeologist, Gavin Hamilton, who lived in Italy and whose six illustrations to Homer, begun about 1761, were seminal not only for the neoclassical style as such but also for the use of the most recent archaeological evidence.[25] In *Priam pleading with Achilles for the Body of Hector* (*c.* 1761–5), for example, he made extensive use of ancient representations of the subject, the composition almost certainly being based on the relief sculpture in the Villa Borghese.[26] Hamilton is therefore a key figure, the more so because he did make one solitary expedition into British history, *Mary Queen of Scots resigning her Crown*, which was commissioned in 1765 by James Boswell, painted in Italy and exhibited at the Royal Academy in 1776. Not only was this the first major visual manifestation of the romantic cult of the Scottish Queen – a Victorian obsession – but in it Hamilton attempted to recreate sixteenth-century Scotland with the same thoroughness that he bestowed on the worlds of ancient Greece and Rome. The figure of Mary is taken from an engraving of a portrait then thought to

28

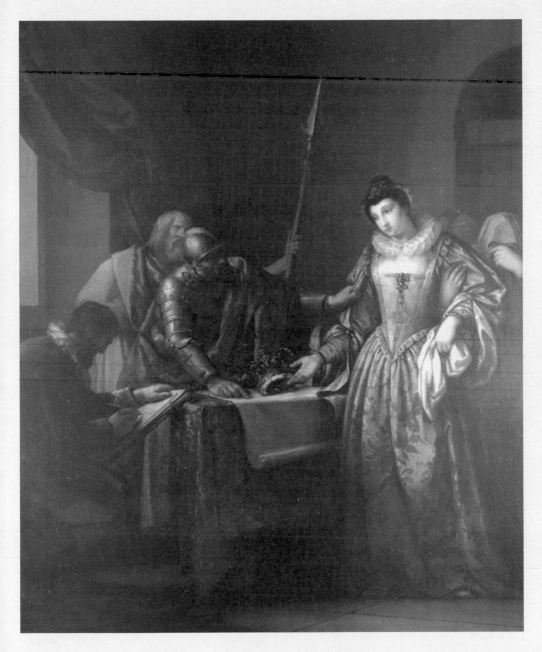

11. Gavin Hamilton's *Mary Queen of Scots resigning her Crown* (1765).

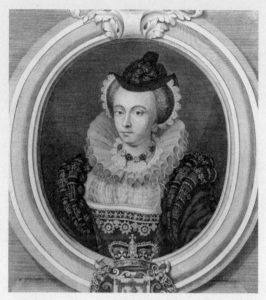

12. Engraving by R. Sheppard
of a miniature thought to
represent Queen Mary.

be of her in the famous collection of Dr Richard Meade, while the
hirsute man in the background is based on the traditional figure of
a wild Scotsman as found in any of a number of manuals of costumes
of the nations issued during the second half of the sixteenth century.[27]

Such an attitude towards accuracy was enormously extended in
the work of Benjamin West, not only in the sphere of the national
past but also when dealing with the events of the present. *The Death
of General Wolfe* (RA 1771) accorded to a contemporary general the
kind of apotheosis normally reserved for the heroes of antiquity, but
the artist reinforced the potency of the image by clothing the
characters in contemporary dress.[28] At the time this was cause for
comment, and provoked the famous intervention by Reynolds to stop
such an innovation, to which West is supposed to have retorted that
the event had taken place in the eighteenth century and 'at a period
of time when no such nations [i.e. Greece and Rome], nor heroes in
their costumes, any longer existed'.[29] The sensational success of this
picture led to the proliferation of scenes from contemporary history,

executed always, of course, according to the idealizing tenets of the history painter, but with the setting and dress of the present.

In doing this, West was only extending the principle which both he and Hamilton had applied earlier to scenes from antiquity. West had initially established his reputation in England as a prime exponent of neoclassicism in the vein of Hamilton seven years before with his picture *The Landing of Agrippina at Brundisium with the Ashes of Germanicus* (1766). The cavalcade here seems to have been based on the Ara Pacis Augustae, fragments of which were then in the Uffizi, and is set against an architectural background derived from the harbour façade of Diocletian's Palace at Split as it appeared in Robert Adam's *The Ruins of the Palace of the Emperor Diocletian, at Spalato* (1764).[30] West was concerned not only with the spirit but, where he was able, with the actuality of the past as revealed by the latest archaeological research.

These instances of his accuracy in contemporary and classical scenes went hand in hand with its application to the British past in a thoroughgoing manner unequalled by any other artist until the Victorian period. From 1778 until his death in 1820, West covered virtually every period of British history. In 1778 he exhibited a scene of mind-boggling obscurity from the Anglo-Saxon period, derived from a passage in the *Itinerary* of the Tudor antiquary John Leland: *William de Albanac presents his three Daughters (naked) to Alfred, the third King of Mercia*. The following year he painted *Alfred the Great divides his Loaf with a Pilgrim* (RA 1779), in 1780 he moved on to the thirteenth century in *Alexander, the third King of Scotland rescued from the Fury of a Stag by the Intrepidity of Colin Fitzgerald* and at about the same time to the Civil War period in *Oliver Cromwell ordering the Mace to be taken away* (1783). From 1787 onwards he was working on his most significant series, on the French wars of Edward III, commissioned by George III for the Audience Chamber at Windsor Castle. His other historical pictures included two for Bowyer's Historic Gallery – *The Citizens of London presenting*

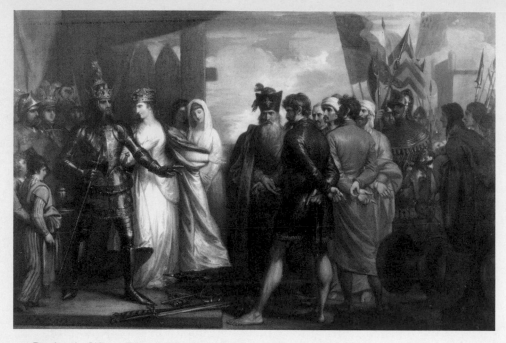

13. Benjamin West, *Edward III and the Burghers of Calais* (1789).

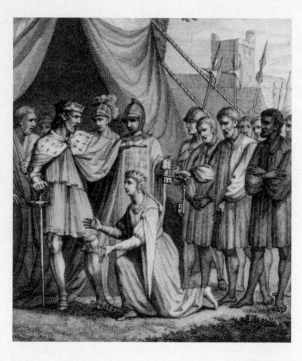

14. John Hall after Edward Edwards, *The Surrender of Calais to Edward III* (1776).

the Crown to William (1808) and *Prince John's Submission to Richard I* – and a group on late Stuart England, *The Landing of Charles II, The Battle of the Boyne* (RA 1780) and *The Destruction of the French Fleet at La Hogue* (RA 1780).[31]

As in the cases of *Wolfe* and *Agrippina*, there is a new level of pictorial accuracy here which can be illustrated by the artist's approach to a single scene from his Edward III series, that depicting *Edward III and the Burghers of Calais* (1789). A comparison with a version by a minor artist, Edward Edwards, of the same scene demonstrates immediately West's enormous advance in archaeological accuracy. As I will show in Part Two, he had consulted the works of the antiquarian Joseph Strutt for information on fourteenth-century dress, weapons and armour. A contemporary records that West's historical research sometimes led him 'to depart from the first plans, as he obtained new historical facts, particularly in the armorial bearings'.[32]

In 1794, to take another instance, West exhibited *Queen Elizabeth going in Procession to St Paul's Cathedral after the Destruction of the Spanish Armada*. The Queen is very carefully depicted, both likeness and dress being the results of a study of contemporary portraits and engravings. Lord Burghley, who bows reverently to her, wears a skullcap and bonnet and leans on his Lord Treasurer's white wand of office. In this case West has succeeded in turning almost full circle the well-known portrait of Burghley as a white-haired Garter Knight. This reveals the vast difference in approach and intent between the Gothick Picturesque and the Artist-Antiquarian treatments of the Elizabethan age.

John Singleton Copley, another American who settled in London in 1774, even more than West, established himself as a leading exponent of heroic scenes from contemporary British political and military life. *Watson and the Shark* (1778), *The Death of the Earl of Chatham* (1779–81), *The Death of Major Peirson* (begun 1782) and *The Siege of Gibraltar* (1783–91) are all detailed re-creations of current events with

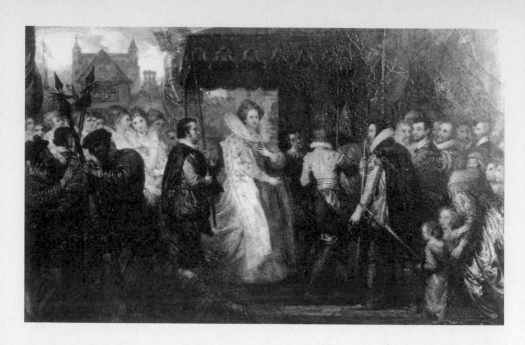

15. Benjamin West's *Queen Elizabeth going in Procession to St Paul's Cathedral after the Destruction of the Spanish Armada* (1794).

16. John Singleton Copley, *Charles I demanding in the House of Commons the Five Impeached Members* (1782–95).

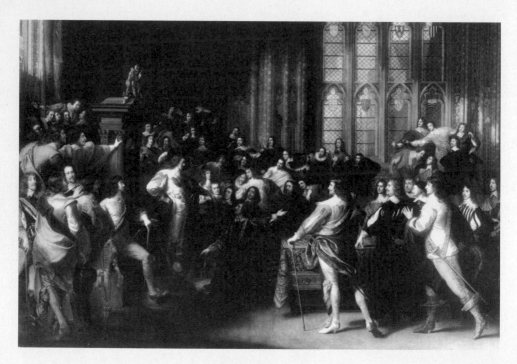

elaborate topographical, portrait and costume research.[33] Like West, Copley also painted religious subjects and episodes from British history. In the last category, his three great contributions were *Charles I demanding in the House of Commons the Five Impeached Members* (1782–95), first exhibited to the public in May 1795, *Monmouth before James II refusing to give the Names of his Accomplices* painted at about the same time, and *The Offer of the Crown to Lady Jane Grey* (1806–7).

It is only necessary to take one of these – the first – to realize the important part which Copley played in the change of approach to history painting. Jules Prown has traced stage by stage the compilation of this picture, from Alderman Boydell's initial approach in 1781 to its completion fourteen years later.[34] The subject was chosen as being the most significant of the many confrontations between the King and the opposition which led up to the outbreak of the Civil War in 1642. Charles I had sent a message demanding the five Members of Parliament who had openly defied him, only to receive an evasive reply, so that he himself went down to the House to demand their arrest. The King asked the Speaker, Sir John Lenthall, whether any of the accused was present. This is the pregnant moment Copley depicts, just before the Speaker's famous reply: 'I have, Sir, neither eyes to see, nor tongue to speak, in this place, but as the house is pleased to direct me, whose servant I am here.'

In tackling this composition Copley's first move was to write to Edward Malone, Shakespearian scholar and historian, who, in a long letter dated 4 January 1782, provided him with a mass of historical data. The picture contains no less than fifty-eight portraits, thirty-six of which were listed by Malone with references as to where Copley could find authentic likenesses in paintings, engravings and medals. Malone, who may actually have suggested the subject to Copley, stated that the best moment to depict would be when Lenthall, kneeling before the King, was about to reply. He even

35

went on to explain where certain of the characters would have been in the House at the time.

With Copley, as with West, we are suddenly in a very different world. The artist has become an antiquarian, seeking the advice of scholars for historical information and correct visual detail.[35] As a result, it was to take over a decade for Copley to put this extraordinary picture together. Periods prior to the eighteenth century were a great deal more troublesome to recreate than were classical or contemporary scenes. The painter inevitably came up against terrible difficulties. Copley's daughter remembered vividly the visits made to old manor houses so that her father could sketch and study particular portraits. What was worse, no portrait actually portrayed the sitter in the year 1642, so that each had to be aged or rejuvenated accordingly. Mercifully, in 1793 there appeared John Thane's *Autography*, an antiquarian biographical history combining portraits of worthies with specimens of their handwriting. Copley clearly had access to this before publication, and he also made extensive use of the 1717 illustrated edition of Clarendon's *History of the Great Rebellion*.

A couple of instances will suffice to show the enormous advance he had made in comparison with the Gothick Picturesque School. Charles I is clearly derived from the celebrated portrait in the Louvre showing him *à la chasse*, but altered to the reverse. Sir Ralph Hopton, who is to the left behind the Speaker's chair, is based on a version of the portrait now in the National Portrait Gallery. One could multiply this research to cover all fifty-eight figures across the picture's surface. In 1795 this was a remarkable achievement, even if as a work of art we now regard the picture as little more than tedious.

It is crucial to grasp the originality of Hamilton, West and Copley within a European context. Everyone now accepts that the British contribution in the 1760s directly inspired a new more serious preoccupation with classical antiquity throughout the Continent; it is less commonly realized that British artists also led the field in exploring the medieval and post-medieval past. But between this

revolutionary achievement and that of their Victorian successors stands a twofold dividing line. On the one hand, the Napoleonic Wars profoundly affected people's attitude to the past and precipitated a renaissance in history writing. More significantly still, a new art form was born which accelerated and transformed everyone's response to the past and gave rise to the third style of painting which I have categorized as Intimate Romantic. This was the historical novel.

The Historical Novel: Scott and Others

Although the historical novel has roots stretching back to Bishop Percy's *Reliques* (1765), Horace Walpole's *Castle of Otranto* (1764) and the whole school of Gothick novelists, for our purposes it began as an art form with the publication of Sir Walter Scott's *Waverley* in 1814. Fleishman in his important study of Scott states that the author 'conceived history from the outset as a past that allowed itself to be made present without losing its double character'.[36] The novels are set in the past, yet they speak in the language of the present. They are no longer the masquerades and mummeries of Walpole, Monk Lewis or Mrs Radcliffe; each is set within a definite historical period and is the product not only of brilliant creative writing and a sustained view of the past but also of real historical research. On the whole Scott is very good on what in theatre would be called his scenery, costumes and props. Although he frequently derides antiquarianism, the strength of his books lies in their basically keen observation of correct period detail.

The historical novel as conceived by Scott viewed the past with sensibility and moral commitment. It placed man, with his complex emotions and reactions, in the web of history, tracing his personal, private response to its great moments. And, as in the case of the new wave of history writing in the post-Napoleonic period, the

historical novel stemmed from the powerful new forces of nation-alism, industrialization and revolution. No age was more intensely nationalistic than the nineteenth century, in which the myth of the historic destiny of the British was inexorably tied up with the whole saga of their history. Britain was the earliest industrialized society in Europe. Its rapid urbanization saw country migrate to town and as the dank dreariness of factory life become a fact it led to nostalgia for an Arcadian golden age vision of Merry England in Olden Time. In the same way, the Napoleonic Wars created a gulf in time when it seemed that all which had gone before belonged to a world that was lost. The nineteenth century as a result felt infinitely more distant from the eighteenth than had the eighteenth from either of the two previous centuries. The historical novel drew on all these threads to create its stories and sustain its readership.

The relationship of Scott to the antiquarians is a significant one, and I will have more to say about it in the next chapter. One instance will suffice to show the importance Scott attached to obtaining correct antiquarian information wherever he could, thereby giving his novels a reality and a power beyond anything achieved by his forerunners in the Gothick style. The novel *Kenilworth* (1821) culminates in 'the Princely Pleasures of Kenilworth', the spectacular entertainments presented by Elizabeth I's favourite, Robert Dudley, Earl of Leicester, in the summer of 1575. For these Scott drew freely on the account by Robert Laneham which had been published by John Nichols in his *Progress of Queen Elizabeth* in the 1820s, but in a subsequent edition he revised his account of Kenilworth Castle in the light of a newly discovered inventory of the household effects sent to him by an anti-quarian friend, William Hamper. This single example of factual accu-racy foreshadows the techniques shortly to be adopted by painters confronted with the same problems of composition.

As a footnote to the impact of Scott, it is important to bear in mind the influence of the various illustrated editions of the Waverley novels. Scott himself supervised the first series of illustrations, which

involved the same principle as did the novels themselves: the integration of actual historical characters and locations with imaginary ones. Illustrations to Scott are therefore of ordinary mortals caught up in the fabric of British history. Hundreds of such illustrations were produced from the 1820s onwards, and all were based on this idea. Scenes from Scott are romantic, dramatic, heroic and yet often extremely domestic, and they extended the grand moral, heroic and patriotic repertory of the Gothick Picturesque School immensely by bringing the past right down to earth in terms of everyday people and events. History became human.

Scott had an enormous impact on the development of history painting – his novels provided subjects for artists as diverse in stature as Eugène Delacroix[37] and William Frederick Yeames – and, in broader terms, on people's attitude to the past. Carlyle summed it up when he wrote: 'These historical novels have taught all men this truth, which looks like a truism, yet was unknown to writers of history and others, till so taught: that the bygone ages of the world were actually filled with living men, not by protocols, state papers, controversies and abstractions of men.'[38] This obvious fact flung wide the door of the past, giving painters unlimited material for their canvases and substituting subjects more human, domestic and anecdotal – and often more trivial – for the heroic scenes seized upon by the eighteenth century. History was no longer the province solely of High Art; it had been opened up to the genre painters, who now abandoned classical Arcadia in favour of May Day in the reign of Elizabeth Tudor or the arrival of the Yule log. And practically no period of the British past went uncovered by the pen of Scott, who dealt with Richard I in *The Talisman* (1825) and *Ivanhoe* (1819), Richard III in *The Fair Maid of Perth* (1828), Mary Queen of Scots in *The Monastery* (1820), Elizabeth I in *Kenilworth* (1821), the Commonwealth in *Woodstock* (1826), Charles II in *Peveril of the Peak* (1823), George I in *Rob Roy* (1817), George II in *Waverley* (1814) and George III in *Redgauntlet* (1824).

Up until about 1850, the historical novel followed the Scott tradition with slight variants.[39] Its prime best-selling exponents were G. P. R. James, Harrison Ainsworth and Edward Bulwer Lytton. James wrote almost a hundred novels based for the most part on French or British history.[40] The first appeared in 1829. He covered the Tudor period in *Darnley; or, the Field of the Cloth of Gold* (1830), *Arabella Stuart* (1844) and *Rizzio* (1849), and the Stuart period, in particular the Civil War, in *Henry Masterton; young Cavalier* (1832), its sequel *The Life and Adventures of John Marston Hall* (1834) and *Bernard Marsh* (1864); several titles dealt with the eighteenth century. He churned out three books a year, and claimed that his re-creations of distant eras were aimed 'to improve and elevate the human mind and to purify and ennoble the heart'. On a higher level came Harrison Ainsworth's still eminently readable novels of the forties, *The Tower of London* (1840), *Old St Paul's* (1841) and *Windsor Castle* (1843). Ainsworth hit upon a neat formula. Each novel takes an existing historical location which is then filled with events and peopled with characters actually connected with the place. On to these is grafted a whole company from the stock grotesquerie of Gothick romance. More serious than either James or Ainsworth was Bulwer Lytton, who designed his elaborate reconstructions of the past as vehicles for moral and ethical lessons for the present.[41] Although his most famous novel, *The Last Days of Pompeii* (1834), was written on a non-British theme, he nevertheless tackled the Wars of the Roses and the Norman Conquest in *The Last of the Barons* (1843) and *Harold* (1848) respectively. In the former he saw mirrored the contemporary struggle of Whig, Tory and Radical, in the latter the defeat of a helpless democratic system by efficient organized despotism.

By the fifties the historical novel had passed its zenith in fashionable esteem. Writers began to delve into the past not so much for the sake of antiquarian pyrotechnics, or to recreate the great moments of history as reflected in their effects on ordinary people,

but rather in order to focus attention on a single individual and his voyage through time in search of his own identity. *Romola* (1862–3), *John Inglesant* (1876) and *The Cloister and the Hearth* (1861) led into a new path, away from the mainstream which had earlier had such an impact on painterly visions of the British past. But through the novel even those who did not read history had been drawn into its web, and writers and painters alike could use the past as a vehicle for contemporary comment.

The Triumph of History and History Painting

The years of the Napoleonic Wars were quite unproductive as far as the writing of history was concerned. This is reflected in Bowyer's ambitious project to illustrate an edition of Hume, still the standard narrative history of England though already almost half a century old. Then, more or less coincidentally with the advent of the historical novel in 1814, came a new phase in history writing.[42] Two books introduced this era: Henry Hallam's *View of the State of Europe during the Middle Ages*, published in 1818, a remarkable advance in the serious study of the medieval period, and Lingard's *History of England*, which appeared the year after and replaced Hume as the standard narrative history throughout the first half of the nineteenth century. These were the years of history as best-selling literature, a period which closed with the death, in 1859, of its presiding genius, Thomas Babington Macaulay. Thomas Carlyle's *French Revolution* (1837) – another subject that obsessed Victorian painters – and Macaulay's *History of England* (1849–61) sold by the thousand, and the new middle classes devoured history with the same kind of hunger as they had for the historical novel. Indeed, for a brief period Macaulay rivalled the fiction writers; Thackeray responded to his success with *Henry Esmond* (1852), an effort to win the captured audience back to the novel. As a result,

there was a profound change in the make-up of the educated person which enabled him to read the iconography of British history on the walls of the Royal Academy each year with eyes of comprehension.

The first half of the nineteenth century throughout Europe witnessed a deliberate attempt to create national mythologies strong enough to hold the minds of the masses who now made up and were necessary to the working of the modern state. In the years immediately following the close of the Napoleonic Wars, conscious historicism reached a peak. There was a longing for the vanished past as unsuccessful efforts were made to put the clock back to the world of the *ancien régime,* and history, seen by the philosophers of the Enlightenment as a triumph of reason over the ignorant feudal absolutism of the past, was now cast as the bearer and realizer of human progress. This was reinforced by the continued belief, inherited from the previous century, that history revealed laws for the proper conduct of affairs. History to the Victorians was practical wisdom. It was presented in nationalistic terms as the evolution of a people and their culture; the past was seen as a purely national affair directly connected with the present state of the country. In Britain this development was prefaced by Sharon Turner's *History of the Anglo-Saxons* (1799–1805) with its eulogy of its subjects as a freedom-loving people from whom stemmed the unique 'liberties' which had saved Britain from the horrors of a revolution of the type which had engulfed and continued to engulf the countries of the mainland of Europe. Such stability made British history of special interest to foreign historians, who saw the country's past as a unique progression to constitutional government, made possible by the struggles of the seventeenth century which, they believed, had averted any equivalent to the French Revolution. This view was enshrined above all in the works of Lord Macaulay, whose *History* went through so many editions during the fifties and sixties. His particular blend of Whig historiography cast the enlightened

ruling classes of England, which had defeated royal absolutism in the seventeenth century, avoided radicalism in the eighteenth and allied themselves with the middle classes by conceding parliamentary reform in the nineteenth, into a role with almost sanctimonious overtones. History of this kind reinforced the ideology of the 'establishment' and restored confidence in its right to rule.

The Victorian age saw the spread of history to the middle and working classes. At the opening of the century, history was essential for men who aspired to a career in politics or administration. After the Reform Bill of 1832, educational reform in the public and in some grammar schools introduced history in order to make the children of the newly enfranchised classes fit for government and political responsibility. It was not until after the 1870 Education Act, however, when history painting was already going into eclipse, that the working class entered into consideration, and the mythology they were to be brought up on was late-Victorian and Edwardian imperialism (another fruitful subject for iconographical analysis).

For the mid-Victorian age the received view of history was overwhelmingly Whig, with its exaltation of the political freedom of the Anglo-Saxons, its celebration of Magna Carta, its interest in the development of Parliament, its belief that the Civil War had reprieved ancient liberties, its fear of revolution and its nurtured complacency. And it was always presented as a story of virtue and vice with morals to be drawn.[43]

'Our annals', wrote Lingard, the great Catholic historian, in the fifth edition (1849) of his *History of England*, 'are fraught with animating scenes of national glory, with bright examples of piety, honour, and resolution, and with the most impressive and instructive lessons to princes, statesmen, and people.'[44] The idea of national history as a quarry for *exempla* for contemporary society is crucial to an understanding of the subject-matter of British nineteenth-century art. The novel was, of course, the greater Victorian art form; painting and sculpture offered no real substitute as vehicles for the ideas

and aspirations of the age. The novel had all the advantages: it could unfold and develop both characters and environment, moving through historic time and the motions of the mind. The nineteenth-century painter had also learnt to move through time, but he could only capture a split second within the frame of his picture.[45] The images he produced presupposed an audience far differently educated and read from that of the previous century. They implied a literate public with a common set of facts, if not uniform attitudes to the past, which enabled them to read these images in a way totally lost to us a century later.

The history of Britain was therefore worthy of celebration by the whole nation, including its painters. History served as a collective genealogy of the new literate middle classes. Moving into the heyday of Victorian England, the public became saturated with history.[46] This development was accelerated by a number of other parallel phenomena: by the Gothic revival in architecture, the Pre-Raphaelite dream-world, Disraeli's Young England group in politics and the Oxford Movement in religion. It was sustained and nourished by the publication of historical memoirs and diaries and the printing of sources, above all the state papers in the Public Record Office, and supported by the proliferation of learned societies – Roxburghe, Shakespeare, Philological, Aelfric, Caxton, Hakluyt, Early English Text, Chaucer, Ballad, English Dialect and Scottish Text. The poets of the Victorian era, as well as its deplorable playwrights, also lived a great deal in the past: Tennyson's *Harold*, *Becket* and *Queen Mary*, Browning's *Strafford* or Swinburne's Mary Stuart trilogy are all evidence of this. And cheap printing and the spread of literacy made the heroic past part of the stock-in-trade of the educated, literate Victorian.

An important development on the visual side was the invention of lithography, which led to the mass-production of cheap illustrated histories of Britain. Charles Knight (1790–1873) was the hero of this popularizing tendency. Three of his publications are of immense

44

importance. Around 1844 he wrote *Old England: A Pictorial Museum of Regal, Ecclesiastical, Municipal, Baronial and Popular Antiquities*, a work produced cheaply and addressed, as were all his subsequent works, to 'the People'. From 1837 onwards, over a period of seven years, Knight published in monthly instalments George Craik and Charles MacFarlane's *Pictorial History of England*, followed from 1850 on by *The Popular History of England*. The latter was designed, as the author stated at the beginning of the book, to tell the masses 'to trace through our annals the essential connection between our political history and our social, to enable people to learn their own history – how they have grown out of slavery, out of feudal wrong, out of regal despotism – into constitutional liberty, and the position of the greatest estate of the realm'. It was completed by 1862, went into an abridged *School History* version in 1865 and was republished for the same use in 1870 as the *Crown History*. These were the books which formulated the concepts of history in the minds of the teeming populace of mid-nineteenth-century Britain – the people who went to the Royal Academy exhibitions or purchased prints after the great history paintings with which to adorn their suburban villas. And into these books, along with prints of old buildings, portraits, views and redrawings from authentic sources, went those very history paintings, for all the world as though there were no difference between the actual past and its contemporary re-creation.[47]

If cheap illustrated books played a large part in popularizing history, so too did museums and galleries. In the past art, both aesthetic and historical, had been in the possession of the aristocracy. Now, through the foundation of public collections, art became part of the visual experience of the middle and lower middle classes. The British Museum, the principal institution exhibiting antiquities in the eighteenth century, was joined in 1824 by the National Gallery and in the 1850s by the Victoria & Albert Museum. By 1900 the National Gallery possessed no less than twenty-three paintings by British artists of scenes from national history.

Whereas the subject-matter of the Gothick Picturesque painters must have come as a recondite surprise to visitors to the Royal Academy in the 1780s and 1790s, by the 1840s and 1850s a generation had grown up to whom the heroes and heroines of British history were infinitely better known and far more comprehensible than the myths of classical antiquity. Painters could now give free expression on canvas to national historic mythologies, assured of immediate understanding from their history-hungry audience. This was an ideal background for the mid-Victorian belief in High Art as the most suitable vehicle to demonstrate the powers of artists of the British School; the desire to excel in history painting inherited from the previous century was now reinforced by the whole thought-context of nineteenth-century Britain. It was a current which was to reach its climax in the commissions for the decoration of Sir Charles Barry's Houses of Parliament.[48] In 1842 the first of a series of competitions was organized for cartoon drawings illustrating subjects from British history or from the works of Spenser, Shakespeare and Milton. The projects – a hundred and forty of them – were unveiled in Westminster Hall in the summer of 1843. To begin with, 1,800 people a day paid to see the cartoons; later the exhibition was made free and the public came in droves, with no less than 4,000 visitors recorded on the final day, 4 September. The winners of the competition were Edward Armitage's *Caesar's Invasion of Britain*, G. F. Watts's *Caractacus led in Triumph through the Streets of Rome* and C. W. Cope's *The First Trial by Jury*. In many ways the competition was a fusion of the Boydell and Bowyer projects, and its products on the whole were equally depressing. But for artist and public alike it represented the climax of nearly a century of struggling to revive history painting in Britain.

It was around this time, too, that the number of history paintings in the Royal Academy annual exhibitions reached its highest level. The statistics on this are not uninteresting, although of course

it is difficult to be absolutely exact.[49] Roughly speaking, the
Academy exhibited about half a dozen historical subjects a year in
the 1820s, up to ten in the thirties, up to or just over twenty in the
forties, between ten and twenty in the fifties, fifteen to twenty in
the sixties and five to fifteen in the seventies, tailing off in the eight-
ies to half a dozen again. In other words, the heyday of the histor-
ical painting was coincidental with the apogee of history writing as
literature. As history itself became an academic discipline, strictly
for professors and dons, at the close of the century, so the paint-
ing of scenes from the British past went into decline.

None the less, the achievement at its best is not to be despised,
and its supreme High Art expression remains more or less intact
to this day in the monumental historical paintings which adorn
the Houses of Parliament. But these monstrously under-appreci-
ated masterpieces by Dyce, Cope and Ward demand yet another
approach, for in order to understand them we must explain the
re-creation of the past as it occurred on the other side of the
Channel.

Intimate Romantic: Bonington, Ingres and the 'Style Troubadour'

Intimate Romantic is a genre which could be presented almost as
an interlude from the main stream, and yet it will take us into the
interrelationship of France and Britain during the renaissance of
romantic antiquarianism in art. As I mentioned earlier, the impact
of Scott and the historical novelists was all-important in opening
up a range of subject-matter to the nineteenth-century artist which
was more domestic, more intimate: glimpses of the private lives of
the great recorded as though we looked not through an archway
into the past, but through a keyhole. The first British painter to
open up this genre was Richard Parkes Bonington. All his life he
was obsessed with history, 'which from the moment our infant artist

47

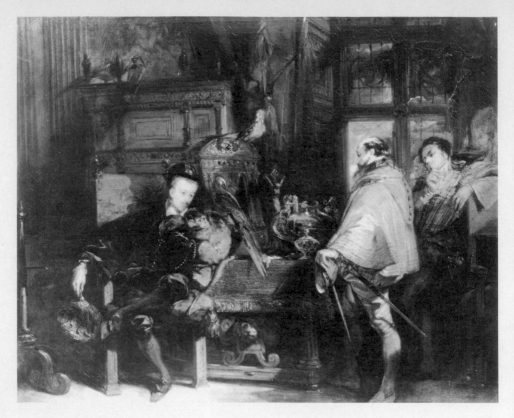

17. Richard Parkes Bonington, *Henry III and the English Ambassador* (1827).

was capable of thought became his favourite study and research',
according to his obituary in the *Gentleman's Magazine* when he died
at the age of twenty-five.[50]

Following in the wake of Copley and West, Bonington was
antiquarian-minded. Sheet after sheet of his sketchbooks is filled
with studies of costume, armour, furniture and architectural detail
which he put down as he studied the contents of a great house, an
armour collection or a medieval manuscript. And Bonington's career
was played out entirely in France. He studied in Paris, first at the
Louvre and later at the Ecole des Beaux-Arts. After the Salon of
1824 he journeyed to England, one of the reasons being to study
the armour in the famous collection of Sir Samuel Rush Meyrick.
It seems to have been here that he first met and befriended the

young Delacroix. On his return to France, Bonington began a series of scenes from French and English history on this theme of the intimate glimpse, the painter turned writer or diarist. These included *The Earl of Surrey and the Fair Geraldine* (1825–6), *Henry IV and the Spanish Ambassador* (1827–8), *Leicester and Amy Robsart* (1827, Ashmolean Museum, Oxford) from Scott's *Kenilworth* and *Henry III and the English Ambassador* (1827). The last of these was exhibited at the 1828 Academy. None of them is a heroic scene momentous for the future of the nation. Only Scott's works could have inspired such re-creations: poet and mistress; a great king *en famille*, his children riding on his back; Queen Elizabeth I's favourite indulging in an illicit amour; and the shock of the English ambassador on seeing Henry III, the last Valois, decadent and effeminate, attended by a minion and carrying a woman's feather fan in his hand. Of the last, it was significantly written in the *Literary Gazette*: 'As a graphic illustration of the character and habits of the French monarch it may be ranked with some of the well-described scenes by Scott in *Quentin Durward* or any other of his historical novels.'[51]

It is significant that Bonington took his passion for the past a stage further. Inspired by Gerard Dou, Vermeer and other Dutch painters of domestic life, he painted the past entirely for itself. *A Child at Prayer* (1825), *Meditation* (1826) or *The Declaration* (1827) are straight historical pastiche, the fount down to our day for hundreds of imitators who depict a never-never land of the past inhabited by models in costume. This aspect of Bonington's work was the source of all the sentimental and anecdotal glimpses of the past which were to pepper the walls of the Royal Academy for the next century.

Meanwhile, across the Channel there had been an even more compulsive preoccupation with the past, intensified by the convulsions of the French Revolution and the career of Napoleon.

Bonington's unique role was as a bridgehead whereby the French *style troubadour* was introduced into England. This style, which was such a feature of painting under the Empire and was patronized

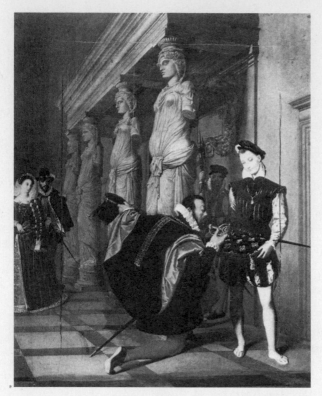

18. Jean-Auguste-
Dominique Ingres,
*Don Pedro de Toledo
kissing Henry IV's
Sword* (1820 version).

by the Empress Josephine, began among the pupils of David during
the revolutionary period.[52] Painters explored the Gothick world,
choosing subject-matter of familial or amorous drama in which they
aimed to combine 'historical interest' and 'ideal beauty' with a
renewed feeling for colour based on a study of Dutch painting.
Aligned to this was a rigid antiquarianism in reconstruction directly
in the tradition of West and Copley. And it is in the work in the
style troubadour of Ingres that we find the vital source which inspired
Bonington and through him the whole tradition of Intimate
Romantic iconography. From 1813 onwards Ingres painted a whole
series of minutely researched reconstructions of the past – *genre
historique*, as they were called – including scenes from the lives of
Raphael, Pietro Aretino, Henry IV and Louis XIV.[53] In the 1824

19. Frederick Goodall, *An Episode of the Happier Days of Charles I* (1853).

Salon he exhibited his *Henry IV surprised by the Spanish Ambassador while playing with his Children* (painted in 1817), a work which must have directly inspired Bonington's composition. Ten years before, in 1814, Ingres had painted one of four versions of *Don Pedro de Toledo kissing Henry IV's Sword* (original version unlocated), again a re-creation not of a grand scene but of an intimate one on the level of an incident recorded in a diary or memoir. Preoccupation with the domestic virtues of Henry IV, always regarded as the ideal healing King of France in the aftermath of war, was natural in a period of return to monarchy which demanded a search into the past for heroic prototypes.

Naturalized into England through Bonington, the Intimate Romantic style was to bear rich fruit above all in the work of William Powell Frith and Augustus Egg. Such artists suddenly found their subject-matter extended so that they could now apply all the standards of historical accuracy needed for the Artist-Antiquarian

51

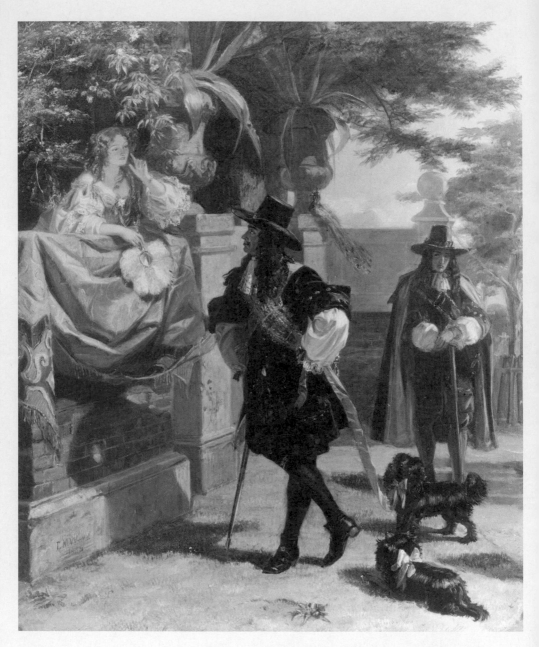

20. Edward Matthew Ward, *Interview between Charles II and Nell Gwynne, as witnessed by Evelyn* (1854).

style to subjects they chose in the Intimate Romantic vein. Thus the Victorian iconography of the British past could include such classic idylls as Frederick Goodall's *An Episode of the Happier Days of Charles I* (1853) and E. M. Ward's witty evocation of Charles II's encounter with Nell Gwyn (1854), both subjects which would have been condemned by the high priests of academic theory in the eighteenth century. History had become the province not only of the history painter but also of the exponents of genre.

Delaroche and British History

If Ingres and Bonington, along with Scott, were central to the establishment of the Intimate Romantic view of the past for the genre painter, the influence in England of Paul Delaroche (1797–1856) was crucial for the climax of the Artist-Antiquarian tradition for the history painter.[54] Delaroche in the 1820s and 1830s recreated the past with a degree of accuracy far in advance of that of his English contemporaries. Although now his work has gone into almost total eclipse, in his day he enjoyed a reputation European in its extent for his grand historical scenes. Through mass-produced prints, Delaroche's set pieces had an enormous influence, and throughout the decade of his greatest success (1825–35) he returned again and again to scenes from British history. His pictures, indeed, would have been more relevant to the walls of the Royal Academy than to those of the Paris Salon. Anglomania was at its height in France in the 1820s and the 1830s, and the obsession with British history went beyond the cult of Sir Walter Scott to include the production of works of serious historical import such as Guizot's *History of the English Revolution* (1826–7) and Victor Hugo's *Cromwell* (1826). Interest in British history, and above all the Civil War period (to which we shall return in greater detail later), was stimulated by post-mortem studies of the French Revolution and the meteoric

21. Paul Delaroche, *Cromwell gazing at the Body of Charles I* (1831).

career of Napoleon. In the English Civil War Frenchmen saw a foreshadowing of 1789, in Cromwell a precursor of Napoleon, in Charles I a forerunner of Louis XVI. In the spectacular and melodramatic ends of British monarchs they were able tactfully to allude to their own rapid changes of dynasty, to the fall of Louis XVI and Marie Antoinette, of Napoleon, Louis XVIII or Louis Philippe.

Through engraving, Delaroche's huge set pieces must have established new standards of historical accuracy to be emulated by the artists who decorated the Houses of Parliament. His antiquarianism was allied to a startling illusion of reality and a genius for choosing moments in which drama intertwined with sentiment. His first scene from British history was on a Jacobite theme, *Flora Macdonald succouring the Young*

Pretender (*c.* 1825), exhibited in the Salon of 1827. Thanks to Scott's novels, the cult of the Jacobites and the fate of Bonnie Prince Charlie were to obsess painters until the close of the century. Delaroche followed this up with his dramatic *Death of Queen Elizabeth* (1828), which placed on canvas a total reversal in attitude to the great English Queen, recording her as a pathetic grovelling hag. In 1831 came *Edward V and the Duke of York* (see page 123), a theme already familiar from the previous century but now painted with a new degree of accuracy and psychological penetration, and in 1831 his macabre *Cromwell gazing at the body of Charles I*, which was exhibited also at the Royal Academy in 1850. In 1834 he showed *The Execution of Lady Jane Grey* (see page 126), in 1837 *Strafford on his Way to Execution* and *The Mocking of Charles I* (see page 147). All these paintings, which were seminal for attitudes to the British past, will be discussed later. Delaroche's only omission was a scene from the life of Mary Queen of Scots; otherwise, he covered all those themes most compelling to the Victorians from their heroic past.

The Painters of the Past

From 1830 onwards, the language of the past was part of the iconographic make-up of every artist of any importance. For some artists it went beyond this to become a major obsession and the most potent vehicle for their ideas. Roughly speaking, the painters who inhabited the past fall into three groups stretching from the post-Napoleonic period to the close of the century. The first contains the earliest essays of the 1820s and 1830s by artists whose main work lay in other genres. They were succeeded during the period 1840–70 by the generation for whom the past was a major ingredient in their intellectual background and in that of their public. By the close of the century, the tide had ebbed, and activity was confined to an ever-shrinking group of Academy painters who attempted to

continue a tradition from which the vitality had already gone.

The most distinguished pioneers of the twenties and thirties were C. R. Leslie and Sir David Wilkie. Wilkie's contribution consisted of three pictures, *Alfred in the Neatherd's Cottage* (1806), *The Preaching of John Knox before the Lords of the Congregation, June 10th, 1559* (1822–32), and *The Escape of Mary Queen of Scots from Lochleven Castle* (1837). They form a minor stream in his work, but the last two were major commissions which reveal him as a brilliant recreator of the past. We know that he was deeply interested in history from the fact that he designed and supervised *tableaux vivants* from Scott novels, enacted at Hatfield for the Marchioness of Salisbury.[55]

C. R. Leslie's career was made in 1818 with his picture *Sir Roger de Coverley going to Church* and in 1821 he exhibited *May Day Revels in the Time of Queen Elizabeth*, a picture twice viewed by Sir Walter Scott, who invited Leslie to Abbotsford and subsequently asked him to contribute illustrations to the Waverley novels.[56] His *Lady Jane Grey prevailed upon to accept the Crown* (1827; see page 126) contributed greatly to the hagiography of that Queen, but in the main Leslie stuck to subjects from literature, from Shakespeare, Cervantes, Goldsmith and Molière.

Turner should be included almost as an interloper, for although he made use of the past in his landscape vision during the thirties, his only overtly antiquarian picture was that of 1831, *Lucy, Countess of Carlisle and Dorothy Percy's Visit to their Father, Lord Percy, when under Attainder upon the Supposition of his being concerned in the Gunpowder Plot*.[57] His use of Van Dyck portraits (actually far too late in date for the event he depicts) in this, his only expedition into British history devoid of landscape, speaks for itself.

The period 1840–70 was the great age of history painting. Its prime exponents were E. M. Ward, Sir Edwin Landseer, Daniel Maclise, Charles Lucy, John Callcott Horsley, Frederick Goodall, Charles Landseer, W. P. Frith, Augustus Egg, John Faed, Eyre Crowe and C. W. Cope. The work of some, such as Egg, Frith and Ward, has already begun to be resurrected, but on the whole a

22. William Dyce, *George Herbert at Bemerton* (1861).

heavy cloud of disapproval hangs over these images of the past. Our attitude to them is still coloured by the verdict, for example, of Graham Reynolds: 'These historical subjects were not felt sufficiently for the artists to enter into them. But they could enter with a sense of participation into those aspects of the world around them which attracted most attention.'[58] This prejudice has led to the exaltation of the painters of scenes of contemporary life and the condemnation of painters of history. It has meant, in the case of Frith, to take the most obvious instance, that his historical works have been ignored and his achievement assessed almost solely in the light of his contemporary genre compositions. How Frith would have hated it! It was not the artists who did not feel sufficiently; it is we, the twentieth-first-century onlookers. Only when we try to relive their excitement as they recaptured the past, as they relived it, as they

used it to point a moral and give hope to a mass audience, can we begin to see these creations in a different light. We have to shed our Bloomsbury prejudice and condescension.

It would be pointless to embark on biographical notices of all these artists. It is not the purpose of this book to review the historical works of each Victorian painter, but rather to recapture an idea. Their works are represented among the illustrations and must speak for themselves. To my eye they are often maligned and underestimated as works of art in their own right. The monumental history paintings of Ward and Cope in the Houses of Parliament are triumphs, not failures. So too are their genre equivalents. W. P. Frith's *Coming of Age in the Olden Time* (1849) and *Claude Duval* (1859) are bravura pieces of genre painting quite as delightful as *Ramsgate Sands* (1854) or *The Railway Station* (1862). Frederick Goodall's *An Episode of the Happier Days of Charles I* (1853) is just as good as, if not better than, his evocations of life in harems. And the work of painters who made only occasional sallies into the British past has given us some of the most haunting pictures of the age: William Dyce's *George Herbert at Bemerton* (1861), William Shakespeare Burton's *A Wounded Cavalier* (1856; see page 151), Ford Madox Brown's *Chaucer at the Court of Edward III* (1856–68; see page 82) or Millais's *Boyhood of Raleigh* (1870; see page 5).

These artists were the great ones, and theirs was the true achievement. After 1870 the driving force had gone and it was left to a small group of establishment artists to take the theme into the present century – Philip Hermogenes Calderon, Sir John Gilbert, Frank Stone, David Wilkie Wynfield, John Seymour Lucas, John Pettie, A. C. Gow and Ernest Crofts. The century of history had reached its close.

Past into Present

But what was it they painted, and why? Statistically, of course, landscape and portraiture far exceeded these historical scenes, but

they did not compare in impact on the public. The study of the complex subject-matter of Victorian art is still in its initial exploratory stages, but it is already clear that the themes cannot be so easily disentangled as they can, for example, in France.[59] There the developments in historic subject-matter can be readily followed: scenes of stoic heroism during the Revolution, followed by the creation of the Napoleonic myth and finally the use of history to buttress the restored Bourbon monarchy. The contrast with England is very marked. History as expressed in scenes of heroic endeavour made very little appearance here during the long years of the Napoleonic Wars, and, as for the monarchy, never was it to sink so low in public esteem as it did in the years after 1815. Neither art nor history was called upon to create any new mythology of monarchy, and there was no real reflection of the ideals of the Crown until the advent of Victoria and Albert in the 1840s. Then Queen and Consort appeared as Anglo-Saxons, as guardians of ancient British liberties, or the family of Charles I was evoked to mirror the domestic bliss of the present royal family. In the iconography of Victoria and Albert the allusions to the past, to *ancien régime* autocracy, were deliberately muted, in contrast to the assertive presentation of George IV. It would, however, take us too far from our path to investigate the subtle idealization of the royal family as it took shape in the forties and fifties. Its central theme would be the use of motifs from Van Dyck to suggest a refinement of bourgeois ideals of family life – a radical distortion of what the portraits of Charles I and his court were really about. Victoria and Albert were presented as knight and lady living out a romance in a chivalrous Victorian dream-world which drew for its imagery on the Caroline. And, like Charles I, they were also seen as ideal parents of an ideal family, a pattern for emulation by their subjects. This mood of chaste romance and domestic virtue drew strength from mirror images in the British past.

On the whole, though, the scenes from history are preoccupied

with the vanishing and transitory nature of monarchy. Imprisonments, executions, the sad fate of exile and defeat in battle are recounted again and again in the persons of Mary Queen of Scots, Lady Jane Grey, Henrietta Maria, Charles I, Charles II, James II and Bonnie Prince Charlie. Perhaps through these figures, comfortably far distant in time, it was possible to meditate on the kind of disaster which was still happening on the mainland of Europe, mirrored above all in the fate of Louis XVI and Marie Antoinette. The miseries of this ill-fated pair harrowed the hearts of visitors to the Royal Academy with as relentless a regularity as did those of the Queen of Scots.

Politically, the subjects from British history focus not on the Crown but on the central issue for the whole period, the reform of elected government by the gradual extension of the franchise. The crucial development in England in the period after 1815 was the resolution of a series of crises in such a way that the old establishment was able to open its doors to the new pillars of power, the industrial cities and the burgeoning middle classes who created and sustained the economic boom of mid-Victorian England. Everyone, regardless of political persuasion, extolled the Anglo-Saxons as the forerunners of later liberties – which 'liberties', of course, were interpreted quite differently according to one's political stance. Alfred the Great was seen as the ideal philosopher-king, Harold as a monarch still to be mourned because with his death at the Battle of Hastings Anglo-Saxon liberty gave way to Norman tyranny and bondage.

This concept of conflict between the old establishment and the new classes found its ideal expression in the Civil War. In the person of Charles I, reinterpreted in the romantic Scott tradition, was discovered the perfect symbol of the *ancien régime* at its best – aristocratic, paternal and pious – as well as an exponent of the virtues of family life. In Cromwell the Chartists and other reformers saw their historic sanction for the new self-made man; they

presented him as the hero of the common people, a man of deep Christian morality, of resolution, courage and decision, even if it meant the destruction of the established order of things. The patterns of passionate and contradictory loyalties at every level were seen in microcosm in the events and personalities of the Civil War. Out of this struggle had been born that most prized possession of British people, the Constitution, monarchic yet democratic, the envy of the rest of Europe. The greatest single visual celebration of this idea survives in the programme of decorations for the Houses of Parliament.

But there are other threads. In an age of renewed evangelical piety and religious revival, patterns of the virtuous life needed reinforcing by example, and although Britain as a Protestant country could not turn to the cult of saints, it could make use of its historic mythology. Kings and queens, poets and writers, statesmen and men of action, as they became known through the spread of literacy and the popular reading of national history, took on roles within a pantheon of virtue and vice. The National Portrait Gallery was founded at the close of the 1850s with precisely this in mind. So history was reduced to a parade of heroes and heroines, which of course could all too easily become trivialized. Sir Thomas More and his family were celebrated as examples of the domestic virtues, while Cardinal Wolsey represented pride before the fall. Loyalty to lost causes animated scene after scene focusing on the Stuarts, on Mary Queen of Scots, on Charles I and Bonnie Prince Charlie. Passionate and romantic loyalty to the losing side is a characteristic of the subject-matter of vast numbers of history pictures. Perhaps, through self-identification, those who suffered reversals at the hands of the forces of change were able to find compensation by surrounding themselves with a haze of romantic, doomed righteousness.

In no other area was history a more useful quarry than in supplying Victorian society with models of ideal womanhood. Perhaps the most revealing of all transmutations was their casting of Mary

Queen of Scots, Lady Jane Grey and Henrietta Maria as examples of the perfect Victorian gentlewoman. Nothing could have been further from historic truth, but the artists remained undeterred by the facts staring them in the face.

Thus history for the Victorians was made a vehicle for a wide variety of political, moral and religious ideas. The events of the British past as reflected in the art of the age were conditioned by a middle-class gloss. These scenes and their heroes were selected to inspire calm, even complacency, with regard to the present. They gave expression and substance to the all-pervasive Whig interpretation of history as progress, with ancient liberties guarded and restored. They were aimed at kindling patriotic pride and moral virtue in the minds of the onlookers, and a fear of revolution. In short, they were history as cast in the mental mould of the post-Reform-Bill electorate. In looking at any nineteenth-century presentation of the past, we should always remember Thomas Buckle's revealing statement in his best-selling *History of Civilisation in England* (1856–61): 'There must always be a connexion between the way in which men contemplate the past, and the way in which they contemplate the present; both views being in fact different forms of the same habits of thought, and therefore presenting in each age, a certain sympathy and correspondence with each other.'[60] This sentence provides the Ariadne's thread for anyone who wishes to unravel the inner meaning of any Victorian vision of the British past.

The Re-creation of the Past

It is not easy actually to recreate the past in the eye of the present. Indeed, it is not altogether possible. We now know that such reconstructions, however brilliant, can never be entirely accurate. Norma Shearer as Marie Antoinette remains entirely a product of her environment, Hollywood in the 1930s, and even that most careful of cinematic evocations, *La Kermesse Héroïque*, which brings to life scenes from Flemish genre painting, ultimately fails in many of its details. A century and a half ago there were no such feelings of failure. Artist and antiquary stood on the brink of a new and startling adventure: they could make the past live again. Through the discoveries of the antiquarian, the artist acquired the almost magical power to waft the onlooker back in a time machine to witness the fall of Clarendon or watch Mary Queen of Scots make her way to the scaffold. The artist seemed to possess superhuman abilities, as though he alone could make time stand still. Although capturing only a single moment, the artist could do something the writer could not: he could actually bring the public face to face with the living reality of their own past. One can understand the obsession of the challenge, one can begin to comprehend the emotions aroused by some of the canvases as visitors to the Royal Academy jostled to see them, one can see how the line between actuality of historical artefact and re-creation in modern painting seemed at times barely to exist. In the early stages it must have been immensely exhilarating.

In order to recreate the past an artist needed to adopt the role of researcher. There was nothing particularly new in this in the sense that ever since the Renaissance there had been a continuous tradition of applying higher standards of pictorial accuracy to painting in respect of classical antiquity. Poussin is an obvious instance, and in eighteenth-century England the impact of the discoveries at Pompeii and Herculaneum was evident in the work of Gavin Hamilton, Josiah Wedgwood and Robert Adam. What was new was the application of this technique to modern periods by artists such as Kent, Hamilton, West and Copley. They began the crusade for the painter to clothe his characters correctly and to place them within an accurate historical environment. Cope's *Charles I erecting his Standard at Nottingham, 1642* (1861) or Brown's *Chaucer at the Court of Edward III* (1856–68) posed problems not only of composition but also of historical research. What was a mid-fourteenth-century lectern like, how did members of the court of Edward III dress, what portrait sources were available for the poet, the King, the Queen and the Prince of Wales? What, in the case of Cope, was armour like in 1642, and who was present at Nottingham when the standard was raised? A hundred such details had to be resolved before the artist could even start. From 1820 onwards such points were studied hard by critics, to the extent that by the middle of the century writers considered any anachronism in a historical composition to be little short of a crime against art itself.

Antiquarianism and the Arts

All this was the consequence of the modest and praiseworthy birth of antiquarianism in the modern sense in England. The importance of the rise of antiquarian studies, and its impact on the whole range of the visual arts during the period 1750–1850, seems to me never to have been fully grasped. This, I think, can be very easily

explained. Antiquarianism can so quickly become the pedestrian, dry-as-dust recording of artefacts from the past that it seems to be quite cut off from the mainstream of creativity in the arts. This may be the case now, but it most certainly was not in the eighteenth century.

Although there had been a Society of Antiquaries in the Elizabethan age, it was not until the close of the second decade of the eighteenth century that it was re-established.[1] The leading light in this revival was William Stukeley, who believed that 'without drawing and designing the study of Antiquitys or any other Science is lame and imperfect'. The Articles of Association included provision for the examination of the 'Relicks of former Ages', including the Roman: of all types of building, sculpture, artefacts, costume, portraits and manuscripts. From the very beginning the new Society commissioned one of its most gifted Fellows, George Vertue, to draw and engrave historical portraits. In its early years the Society was medieval and Tudor in its antiquarian preoccupations, but the classical upsurge of the thirties reached a crescendo in the fifties when Robert Adam, Richard Wilson, James 'Athenian' Stuart, Francesco Bartolozzi and Giovanni Battista Cipriani were Fellows. By the seventies, medieval studies had reasserted themselves. Moving into the new century, a list of Fellows includes several of importance for the re-creation of the past in architecture, interior decoration and painting: Benjamin West (elected 1792), Francis Chantrey, the sculptor, and Charles Alfred Stothard, the artist and antiquary (both 1819), Edward Blore, architect of Scott's Abbotsford and Meyrick's Goodrich (1823) and Anthony Salvin and John Nash, architects.

In other words, the Society of Antiquaries in the eighteenth and early nineteenth centuries was not merely a closed world of antiquarians, but actually numbered among its members many of the most influential creators of the age. Particularly important was their steady production of engravings of the visual sources of the past, the series of prints bound up as *Vetusta Monumenta* (1747 onwards)

and *Archaeologia* (1770 onwards), their illustrated journal of learned communication. These were available for use even by those who ridiculed the antiquarian – an attitude succinctly caught by Horace Walpole in a letter to Cole in September 1778:

The antiquaries will be as ridiculous as they used to be; and since it is impossible to infuse taste into them, they will be as dry and dull as their predecessors. One may revive what perished, but it will perish again, if more life is not breathed into it than it enjoyed originally. Facts, dates and names will never please the multitude, unless there is some style and manner to recommend them, and unless some novelty is struck out from their appearance. The best merit of the Society lies in their prints; for their volumes, no mortal will ever touch them but an antiquary.[2]

The work of the antiquarians in the field of architecture has long been recognized as significant by architectural historians, for it gave rise to the revivalist styles of the eighteenth and nineteenth centuries. By comparison, the lesser paths of costume, armour, portraiture or antique furniture – all crucial for piecing together the past – remain little explored. And yet the work carried out by scholars and antiquarians at the close of the eighteenth century and into the nineteenth century had a profound effect not only on the advance of scholarship, but also on theatrical production, interior decoration, furniture design and, of course, on painters, giving them the material they needed, in an age before museums, to paint their visions of the Britain of other ages. In the explosion of antiquarian activity that characterized the first half of the nineteenth century, the discoveries of the previous century were extended and popularized. These were now codified for artist and public alike in book after book on historical architecture, furniture, portraiture, costume, armour and weapons. And these are the handbooks which made the vision possible, and which we must now turn to study.

Historic Dress: Strutt, Planché, Fairholt and Others

The documentation of historic dress was included amongst other objectives listed by Humphrey Wanley in his draft for the foundation of a society of antiquaries about 1708.[3] This was to cover not only clothes of every rank and class in society, but also armour and weapons. Seventy years, however, were to elapse before this subject of antiquarian research was in fact taken up. For most of the eighteenth century ideas as to correct historical costume were extremely vague. There were no English books on the subject, and indeed very little published material apart from the volumes depicting costumes of the nations which had been produced in Italy and Flanders in the second half of the sixteenth century. These included standard works such as Cesare Vecellio's *Habiti Antichi e Moderni* (1590) and Boissard's *Habitus Variarum Orbis Gentium* (1581). Such books, illustrated with engravings of hundreds of costumes, became part of the reference library of any painter, much as the manuals by Cartari and Ripa were essential for the attributes of the classical gods and goddesses.

The first stirrings of an awareness of historical dress can be traced to the 1730s, and more particularly to the stage. In 1737 a tragedy on the life of Charles I was staged 'Dressed after the Manner of the Time',[4] but it was not until Garrick's reforms of stage costume in the 1740s that any serious attempt was made at correct dress. Even then, its effect was parallel to that of the clothes which appeared in the Gothick Picturesque phase of history painting; this phase lasted just as long on the stage, ending in 1824 when Planché supervised Kemble's production of *King John*. Hogarth's famous portrait of Garrick as Richard III (*c*. 1745) illustrates the Gothick theatrical style, in which the actor has abandoned contemporary dress for a costume reminiscent of the Tudor period. Little advance was made on this for over half a century, as a glance at any of the paintings commissioned by Alderman Boydell for his Shakespeare

Gallery in the 1780s will prove. That high priest of the academic tradition, Reynolds, indeed objected to scenes in medieval or modern dress because, he said, 'the effect . . . will always be mean and vulgar'; yet he also felt that 'to depart from the Costume is as bad on the other side',[5] which effectively ruled out this kind of subject-matter altogether. The controversy was still alive during the 1840s, when it affected the choice of subjects in the competitions for the decoration of the Houses of Parliament.[6]

It was to take almost half a century for the researches of one man to have an effect both on painting and stage production. The most important single figure in the investigation of the costume of the past was Joseph Strutt.[7] Born in 1749, the son of a wealthy miller, he received a grammar school education, after which he was apprenticed to an engraver. In 1770 he entered the Royal Academy Schools, and the year after became a student in the British Museum Reading Room. Strutt's first, extraordinary book, *The Regal and Ecclesiastical Antiquities of England*, appeared in 1773, when he was twenty-four. It was an amazing and original contribution to antiquarian studies from someone who had virtually been self-taught. He was to follow this over a period of thirty years with a whole series of profusely illustrated and elaborately researched books, all basically of the same type, publishing the visual sources for English social and domestic history: three volumes entitled *Honda Angel-cynnan or, A compleat View of the Manners, Customs, Arms, Habits, etc. of the Inhabitants of England* . . . (1774–6), two volumes out of a projected six of *The Chronicle of England* (1777–8) and, finally, two books which were as seminal as his first – *A Complete View of the Dress and Habits of the People of England* (1796–9) and *Sports and Pastimes of the People of England* (1801). Burrowing, as no one else had ever done, through a morass of visual and written evidence, together with early printed source material, he pieced together for the very first time a picture of everyday life in England from the Anglo-Saxons down to the Tudor age. The consequences were

revolutionary for the art of historical reconstruction, and it was Strutt more than any other person who gave the painters of the new Artist-Antiquarian phase the sources that they so desperately needed.

A full-length book on Strutt is a desideratum, as he emerges as an influential but totally neglected figure in the history of art in Britain. His guiding star and inspiration was the great French antiquarian Montfaucon. We need only consider two of Strutt's works, which will show his method in action. *Regal and Ecclesiastical*

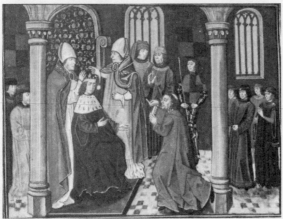

23 and 24. The quest for accuracy begins: plate XXXVIII (*left*) from Joseph Strutt, *The Regal and Ecclesiastical Antiquities of England* (1773) is based on an illustration (*above*) from Royal MS. 18 E. II depicting the coronation of Henry IV.

Antiquities, which ran into a second edition in 1793 and a third, edited by Planché, in 1842, is made up of a series of engravings of the monarchs of England from Edward the Confessor to Henry VIII, together with other notabilities. Each, Strutt states, is 'correctly copied from the ORIGINALS, which particularly expressed the DRESS and CUSTOMS of the Time, to which each Piece respectively relates'.[8] Plate XXXVIII, for instance, is taken from British Museum Royal MS. 18 E.II and depicts the coronation of Henry IV at Westminster by the Archbishops of Canterbury and York. There is a long footnote by Strutt as to the exact colour of the robes in the illumination.[9] The book contains sixty plates of this type in all, and Strutt states that he produced it not only for the benefit of those to whom he alludes as 'the curious', but more particularly for artists, so that 'those that have occasion to represent scenes from the ancient English history, may find the dress and character'. 'Hitherto', he continues, 'our artists have been extremely deficient in their delineations of the early history – the Saxons are drawn in the habit of the figures on the Trajan and Antonine columns; and the Normans are put into the dresses and armour worn in Edward the Fourth's time, and indeed, are often made still more modern.'[10] What a manifesto from a young man of twenty-four! It was the death knell of the fancy dress masquerades of a Wheatley or Downman. None the less, Strutt charitably defends these artists of the Gothick Picturesque School, because until the publication of his book the sources were not available to them, so that they had been prevented from achieving 'the truth of antiquity'.

The impact of Strutt's *Regal and Ecclesiastical Antiquities* was minimal in comparison with the enormous influence exerted by his *Complete View of the Dress and Habits of the People of England*. Here, as in the earlier book, Strutt had produced something entirely original – the first systematic documented history of dress from the earliest times down to the close of the fifteenth century. He chose to end at the point where source material in the form of portraits and engravings

became more plentiful. Strutt was acutely aware of the originality of his production:

> The Engravings, which form the most material part of this publication, are taken from drawings in Manuscripts coeval with the times that they are intended to illustrate, or other monuments of antiquity equally authentic; and they are faithfully copied from the originals, without additional folds being made to the draperies or the least deviation from the form of the garments.[11]

Strutt's *Dress and Habits* became a fundamental source book for all painters, not only in its own right but also because it was ruthlessly plagiarized by the two great costume historians of the nineteenth century, Planché and Fairholt. Through them the costume figures of Strutt reached a far wider audience, and continue to have a life in histories of costume, unbelievably, down to the present day.

Strutt's own publication is a monument to the antiquarian standards of its period. He used the evidence of archaeology for the earliest ages, but in the main he relied on manuscript illuminations in the British Museum Royal, Harleian and Sloane collections, with occasional items drawn from the Bodleian Library in Oxford. Each illustration is carefully documented, revealing the wide range of original historical material consulted: chronicles, legal documents in the form of sumptuary legislation, manuscripts plus literary sources of every kind. But it is the illustrations above all which are the most important, for Strutt opened up, for the very first time, a window into the English Middle Ages, carefully selecting illustrations to depict all levels of society – rustics, noblemen, lawyers, merchants, officers of state, ecclesiastics – and all types of costume: travelling dress, masquerade attire, dresses for young ladies and for matrons, hunting costume, soldiers' gear, monastic habits. We need only look at one illustration to demonstrate his method.

25.–27. Strutt, in plate XCIII of *The Dress and Habits* (*above*), combined figures from Royal MS. 15 D. III (*top left*) and Royal MS. 16 G. V (*top right*).

Plate XCIII, 'Ladies of High Rank of the 14th Century', is typical
of many plates which amalgamate single figures from more than
one source. The figures on the left and right are taken from Royal
MS. 15 D. III, while the centre figure is from Royal MS. 16 G. V,
Gestes des Roi de France, a manuscript which had belonged to
Humphrey, Duke of Gloucester. The latter Strutt drew upon for
no less than ten other costume figures.

Inevitably, redrawing leads to inaccuracy, but Strutt's fidelity is
remarkable for his period, and his technique of rearranging
costume figures from various original sources in tableaux evoca-
tive of life in a distant age is richly suggestive of the possibilities
of such historical reconstruction. One can see how Strutt's mind
moved on to another, irresistible stage. He had recreated the past;
all that remained for him to do was to animate it, to breathe into
it life and speech, action and plot. The figures would then move,
the robes flow, the plumes nod, the veils flutter, the burghers and
nobility would exchange words, the arms of the knights would once
more resound, the horsemen would gallop. From *The Dress and
Habits* to an antiquarian historical novel must have seemed a short
step, and Strutt took it. After his other important book, *The Sports
and Pastimes of the People of England* (essential to the Victorian myth
of Merry England in Olden Time), he embarked on a novel entitled
Queenhoo-Hall, a romance set in fifteenth-century England to illus-
trate its manners, customs and habits. Strutt died in October 1802
leaving it unfinished. John Murray, the publisher, passed it on to
Scott, who completed it rather badly. A few years later, however,
it inspired Scott to write *Waverley*, so we can understand the signif-
icance of Strutt from every point of view. It is possible to grasp
also the integral links which existed between antiquarians, writers
and artists as the doorway to the past was opened. We are able to
share their excitement as they began to make the figures of history
move and speak once more upon the stage of the British past.

Strutt towers above every other figure in the history of dress in

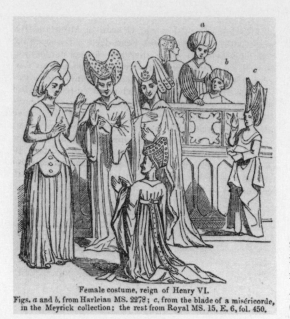

Female costume, reign of Henry VI.
Figs. *a* and *b*, from Harleian MS. 2278; *c*, from the blade of a miséricorde, in the Meyrick collection; the rest from Royal MS. 15, E, 6, fol. 450.

28. James Planché illustrated 'Female costume, reign of Henry VI' in his *History of British Costume* (1834).

England. Planché and Fairholt, in contrast, were essentially popularizers. James Planché (1796–1880) combined a somewhat unlikely career as a highly successful writer of burlesques and harlequinades with that of an antiquary and scholar of heraldry and costume, something which led him eventually to be appointed to the College of Arms. Such activities were not mutually exclusive, and in 1824 Planché supervised a landmark in theatrical production, Charles Kemble's revival of Shakespeare's *King John* at Drury Lane, the first occasion on which a Shakespearian production was staged with correct historical costume. Planché acknowledges, however, that Kemble had earlier consulted Douce, the antiquarian, on the staging of the Roman plays, which emphasizes the fact that accuracy in the archaeological detail of the ancient world went hand in hand with accuracy in respect of the post-classical eras. Planché's designs for *King John* were subsequently published in three volumes, but his most important book was the *History of British Costume*, written with the encouragement of Douce and Meyrick and published in 1834.

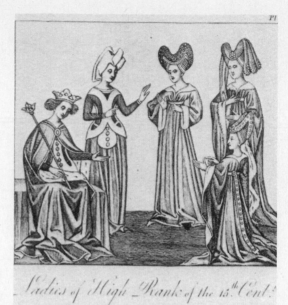

29. Planché made use of Strutt's plate CXIX from *The Dress and Habits*.

This ran into two more editions, in 1847 and 1874, and was designed from the outset to preserve artists from committing grave errors in their representation of the costume of the past. Planché says that the painter is now expected to depict the past accurately, and if he fails to do so he abuses 'the faith accorded to him' by the public as 'an illustrator of habits and manners'.[12] He praises the genius and learning of Sir Walter Scott, although even he in *Ivanhoe* describes armour more suitable to the sixteenth than the twelfth century. 'Antiquities', Planché roundly declares, 'are now considered valuable only in proportion to their illustration of history or their importance to art.'[13] His book is largely derived from Strutt, but it is an immense improvement in arrangement in that the material is now presented chronologically, reign by reign; what is more, he carries the story beyond the early Tudors and on to the close of the reign of George III. The quality of the illustrations is frankly deplorable compared with those of Strutt, and in spite of his numerous references to the original manuscript sources it would be surpris-

ing if Planché ever looked at the majority of them. One illustration is sufficient to show his method. A group of fifteenth-century ladies is a combination of figures from two separate plates in *The Dress and Habits,* for which Strutt had already combined more than one source in the first place![14]

The second popularizer, Frederick William Fairholt (1814–1866), like Strutt and Planché, was a self-taught antiquary. He came of extremely humble origins and made his reputation as a prolific engraver of historical subjects, immensely in demand because of his antiquarian knowledge and fidelity as a draughtsman. He illustrated Hall's *Mansions of England* (1843–5), Halliwell's *Life of William Shakespeare* (1848) and the proceedings of the major antiquarian societies of the day. In 1846 he produced his *Costume in England*, which went into a second edition fourteen years later. The preface to the 1860 edition, written at the high point of the art of the artist-antiquarian, is worth quoting for its categorical statement on the role of historical accuracy in art, much more stringent than Planché's a generation before:

As no historian could venture to give wrong dates designedly, so no painter should falsify history by delineating the character on his canvas in habits not known until many years after their death, or holding implements that were not at the time invented. Whatever talent may be displayed in the drawing, grouping, and colouring of such pictures they are but 'painted lies' and cannot be excused any more than history that falsifies fact and dates would be, although clothed in all the flowers of rhetoric.[15]

By 1860 inaccuracy had become a crime against art, and art had been led hard along the sterile path of pedantic historical reconstruction. Here again there is a rifling of Strutt's sources,[16] but Fairholt, unlike Planché, seems to have consulted the originals. A

30. Frederick William Fairholt, *Costume in England* (1846), also based on Strutt.

fifteenth-century couple, for instance, come directly from Royal MS. 15 D. III and are not split up as they are by Strutt (see page 72).[17] Fairholt too continues the story down to the reign of George III, ending with a few feeble cuts after Heideloff's *Gallery of English Fashion*.

Planché and Fairholt also assimilated into their works three other major contributions to the rediscovery of the dress of the past, Charles Alfred Stothard's *The Monumental Effigies of Great Britain* (1811–33), Francis Grose's *A Treatise on Ancient Armour and Weapons* (1786) and Sir Samuel Rush Meyrick's *A Critical Inquiry into Antient Armour, as it existed in Europe, but particularly in England, from the Norman Conquest to the Reign of King Charles II* (1824). Stothard (1786–1821), who was historical draughtsman to the Society of Antiquaries, embarked in 1811 on his vast work on effigies, a subject already opened up at the end of the previous century by Richard Gough, whose *Sepulchral Monuments of Great Britain* appeared between 1786 and 1799. Stothard unfortunately died before he was able to complete his work by falling off a ladder while copying figures from a stained-glass window in a remote Devonshire church. His prime motivation had been the service that 'these Monumental effigies would render the Historical Painter', the straight historian and biographer and the theatrical

31. Stothard's details of the effigy of Sir Thomas Cawne in Ightham church, Kent.

costumier. The frontispiece to this massive work, in which the tomb effigies of the famous in British history rise to life from the grave, captures beautifully the ambience of early-nineteenth-century anti-quarianism. 'By these means,' Stothard wrote, 'we live in other ages

78

than our own . . . In some measure we arrest the fleeting steps of Time, and again review those things his arm has passed over, and subdued, but not destroyed.'[18] The book is made up of hundreds of plates rich in information on English medieval costume and portraiture. And it was, as I indicated, shamelessly plagiarized by Planché and Fairholt. Stothard had a continuous stream of successors throughout the Victorian period and right down to the present day.

Armour and the weapons of war were subjects first essayed by Francis Grose (1731–91), also an Antiquary, whose contributions included *Military Antiquities respecting a History of the English Army from the Conquest to the Present Time* (1786–8), which went into further editions in 1801 and 1812, and *The Antiquarian Repertory* (1775). But it was his *Treatise on Ancient Armour and Weapons* (1786) which was aimed specifically at the painters of history as well as antiquarians and those bent on a study of the curious. Grose hoped that it might 'be useful to sculptors, painters, and designers, and enable them to avoid those anachronisms and violations of the *coustume*, which we too often meet with in works otherwise excellently performed'.[19] Forty-two plates illustrate whole suits of armour and pieces, weapons and horse furniture. As an instance of antiquarian research it is far inferior to Strutt. Edward III, for example, is shown in armour of the Tudor rather than the Plantagenet period.

Sir Samuel Rush Meyrick (1783–1848) was likewise an Antiquary and took an active part in the affairs of the Society. Later he assisted in the formation of the British Archaeological Association. His earliest publication was on British costume down to the sixth century,[20] but his fame and influence rested on the critical study of ancient armour and weapons. As we have seen, Bonington and Delacroix met while studying and drawing examples of armour from the remarkable collection he had assembled first in London and later at Goodrich Court, the Gothick fantasy which he built himself in Herefordshire. Writing in the preface to the 1824 edition

RICHARD THE FIRST KING OF ENGLAND

A.D.1194.

32. Antiquarian research
into armour and weaponry:
composition from Sir
Samuel Rush Meyrick,
*A Critical Inquiry into Antient
Armour* . . . (1824).

of his work, Meyrick stated that his main aim had been to estab-
lish a chronology of armour, which until then had been imperfectly
understood by writers, painters and dramatists. The barons of the
reign of King John, for example, would be made to wear armour
of the period of Edward I. Recent research on the history of dress
'had not only given a general stimulus to the arts, but introduced
into paintings and scenic representations of all kinds an historical
correctness with which our ancestors were unacquainted'. He
ridiculed artists, West among them, who used the Tower Armouries
as their only quarry when these did not contain a single suit dating
from before the reign of Henry VIII.[21] In the tradition of Strutt,
this is an immensely erudite work, profusely if melodramatically
illustrated with coloured engravings of knights of every period. The
book is a tremendous leap forward from Grose, but the illustrations

33. A knight from Grose's
*Treatise on Ancient Armour
and Weapons*.

are tableaux from the medieval novels of Meyrick's friend, Sir Walter Scott.[22]

What was the influence of all these manuals? The first artist to 'come at the truth of antiquity' by means of Strutt was Benjamin West. *Regal and Ecclesiastical Antiquities* appeared in time to be used by West for his monumental series of paintings for George III on the French wars of Edward III. Moving on in time, we can see such instances increasing in number as antiquarianism came to preoccupy the painters. Thomas Stothard, father of the compiler of the *Monumental Effigies* and a prolific artist mainly in the Gothick Picturesque manner, used Strutt for the dresses of the medieval pilgrims in his most famous picture, *The Pilgrimage to Canterbury* (1806–7). Twenty years later, Bonington used Strutt even more directly for his picture of *Anne Page and Slender* (1826). Ford Madox

34. Ford Madox Brown's *Chaucer at the Court of Edward III* (1856–68).

35. 'Ladies' Head Dresses of the 14th Century', from Strutt's *Dress and Habits*.

Brown's *Chaucer at the Court of Edward III*, painted during the period 1856–68, again made use of Strutt for the ladies' headdresses, and the artist went on to use the Westminster tomb effigy of the King and the Canterbury Cathedral tomb effigy of the Prince, both drawn almost certainly from Stothard's *Monumental Effigies*. The result is slightly odd, as the Black Prince stands in full battle armour at an informal social gathering! In addition, Brown made use of the colourful illustrations in a French costume book, Camille Bonnard's *Costume Historique* (1829–30).[23] These few examples could be multiplied as we move into the High Victorian period, where every item on the surface of a historical canvas had to have its correct source.

By then, of course, artists were busy making costumes or hiring them from theatrical costumiers, but the sources were the same.

Rossetti's visions of medieval romance are arrayed in clothes of the reign of Edward III which he had made up for him. We catch glimpses of this in letters written in the early seventies, when the artist was trying to locate what can only be described as his 'studio wardrobe' of medieval costume. 'Neither can I guess at all', Rossetti wrote, 'what has become of all the mediaeval costumes I used to have. For instance, I remember distinctly one woman's dress – cote-hardie, open up sides and kirtle to go under it – of white velvet quartered with yellow. This is not in your list and there were a number of men's dresses I know, not one of which seems to be extant.'[24]

Thackeray's amusing reviews of Royal Academy exhibitions in the 1840s, when accuracy in dress became a major preoccupation, are revealing on the attitude of both critics and public. Condemning Alfred Elmore's representation of Thomas à Becket with a 'black cassock beneath his canonicals', he writes: 'A painter should be as careful about his costumes as an historian about his dates.'[25] A bouquet is then handed to Charles Landseer for accuracy but, alas, 'the gentlemen and ladies do not look as though they were accustomed to their dresses, for all their correctness, and had put them on for the first time'[26] – which they probably had! Four years later, in 1844, he wrote of John Herbert's *The Trial of the Seven Bishops*: 'In his attention to dress, Mr Herbert's picture is very praise-worthy; the men are quite at home in their quaint coats and peri-wigs of James the Second's time; the ladies in their stiff, long-waisted gowns, their fans, and their queer caps and patches.'[27] In these critical comments, which can be endlessly duplicated from other reviews of the Academy exhibitions, we witness the triumph of the costume historian.

In the small world of early- to mid-Victorian art and letters, the costume historians also acted directly as consultants on dress. Planché's *Recollections and Reflections* (1872) vividly recount the part he played in advising the history painters of the day. He was, for

example, summoned to correct Wilkie on historical detail in his celebrated picture of John Knox preaching, although his information was promptly ignored.[28] He also helped Benjamin Robert Haydon over details in a vast canvas depicting the Black Prince thanking Lord Audley for his valour at the Battle of Poitiers.[29] Haydon wrote to Planché stating his belief in the artist's role as purveyor of historical truth.[30] Maclise sent the following request when he was about to start on his painting *An Interview between Charles I and Oliver Cromwell* (see page 145) in January 1836:

> Boldly then I would beg of you, if it were in your power, to put me in the way of getting a dress of Charles I., by borrowing or begging, or even if I knew the address of a stage tailor I would give him an order and some black silk. I am about to paint a picture of Charles and Cromwell and Ireton, &c., and the dresses must be faithfully rendered. The picture being lifesize we are forced to have the materials to paint from.[31]

Planché goes on to remember how his 'good friend and master', Sir Samuel Rush Meyrick, advised the minor artist, Abraham Cooper, on his *Bosworth Field* (1825), and explains how his own reputation as an authority on historic dress brought within his orbit most of the art establishment: Henry Perronet Briggs, William Etty, Charles and Edwin Landseer, George Cattermole, Bonington, Sir Charles Eastlake, Alfred and John Chalon.[32] Even at the age of eighty-two, he was approached by Millais for information on how to clothe the two boys for his picture of *The Princes in the Tower*. As a footnote, we know that Fairholt did the same thing, for William Powell Frith records his help in connection with the picture of *Claude Duval* (1859).

One final point which should perhaps be briefly mentioned is the simultaneous movement towards period accuracy in scenery and costume in the theatre. Like so many other facets of the

36. Engraving by Vertue of
Lord Burghley, from
Thomas Birch, *Heads of
Illustrious Persons* (1747–52).

relationship of antiquarianism to the arts in the nineteenth century,
this really deserves a book on its own. As established by Planché in
his famous production of *King John* in 1824, the theatre was one of
the greatest vehicles whereby the present could indulge in recreations
of times past. And Planché was a crucial pace-setter in the field; in
1834, for instance, he placed on stage the 'Hampton Court Beauties',
based on the famous series of portraits by Sir Peter Lely. There
was, in fact, a constant interplay between historical subject-matter
on the stage and its manifestation in the visual arts.[33] Beyond even
this, Planché leads us to a final, almost trivial nuance: the vogue
for the costume ball. The three great costume balls given by Queen
Victoria and the Prince Consort in the late forties and early fifties
all had Planché as their consultant. Through them, past was assim-
ilated to present for a night as the upper classes played the parts of

37. Portrait of Anne Boleyn
included by Edmund
Lodge in his *Portraits of
Illustrious Personages of Great
Britain* (1821–34).

their ancestors from the courts of Edward III, George II and
Charles II.

The Faces of the Past: Vertue to Lodge

Ford Madox Brown's *Chaucer* is not only concerned with correct
costume; it shows portrait likenesses based on tomb effigies. As in
the case of dress, the Society of Antiquaries from its inception was
greatly involved with the engraving and publication of portraits
from the past. For this purpose George Vertue was employed as
official draughtsman. In 1718, for example, he was asked to engrave
for them the full-length portrait of Richard II in Westminster
Abbey.[34] The year after, he was sent to Kensington Palace to inspect

Remy van Leemput's copy of Holbein's destroyed wall-painting depicting the family of Henry VII, which he also subsequently engraved. At the same time the Society, like Queen Caroline, began to collect historical portraits.[35] As we saw, Vertue's greatest contribution was the portraits of kings and queens in the illustrated edition of Rapin, but he also went on to engrave a hundred portraits for Thomas Birch's *Heads of Illustrious Persons* (1747–52), which went into a second edition in 1813.

This portrait mania was intensified by James Granger's *Biographical History of England* (1769–74), a huge compilation of biographies and anecdotes combined with a list of all known engraved likenesses designed as 'a help to the knowledge of portraiture'. This led to the creation of extra-illustrated editions into which were inserted as many of the engravings he listed as possible, with a consequent terrifying defacement of early printed books. Later came the publication of books of engraved historical portraits designed specifically to illustrate Granger: *Richardson's Collection* (1792–1812), *Woodburn's Gallery of Rare Portraits* (1816) and *A Collection of Portraits to illustrate Granger's Biographical History* (1820–22). In addition to this,

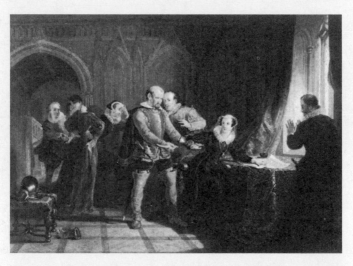

38. An engraving after Sir William Allan's *Lord Lindsay compelling Mary to abdicate* (1824).

39. The 'Oudry Portrait' on which Allan's likeness is based.

the pioneering work of Vertue was taken up again by John Thane, whose *Autography* (1776) combined portraits with specimens of handwriting.

Most of this passed by unnoticed as far as the painters in the Gothick Picturesque manner were concerned. It was not until the 1820s that historical portraiture became definite in its reference, and this movement is epitomized by one book, Edmund Lodge's *Portraits of Illustrious Personages of Great Britain*. Like Planché, Lodge was a herald, and his interest in portraiture began with biography. He undertook, for instance, the biographies for John Chamberlaine's *Imitations of Original Drawings by Hans Holbein* (1792–1812), in which the famous portrait drawings were published for the first time. As a handbook for artists, *Portraits of Illustrious Personages* occupied a place comparable to that of Planché and

Fairholt. In 1850 the *Art Journal* wrote of it as 'a valuable authority for costume and identical impersonation'.[36] No artist who wished to people his canvases with the great of the past could afford to be without this vade-mecum, in which portraits appeared side by side with a series of pleasantly written biographical and historical memoirs. The walls of the great houses of England – Hatfield, Petworth, Knowsley, Cassiobury, Penshurst, Wilton and Woburn – had been scoured for true likenesses of these famous characters. The work was initially published in forty parts from 1814 onwards. A collected edition was issued in four mammoth volumes between 1821 and 1834, and a second in twelve volumes in 1835, and finally it was made available to a mass public in an eight-volume edition issued in 1849–50 by Bohn's Illustrated Library.

Once again we sense the influence of Sir Walter Scott, whose letter printed in the 1821 edition sums up the tremendous appeal of this book to those who wished to voyage into the past: 'It is impossible for me to conceive a work more interesting to the present age than that which exhibits before our eyes our "fathers as they lived", to compare their persons and countenances with their sentiments and actions.'[37]

The heyday of Lodge's *Portraits* takes us right up to the era of the mass popularization of antiquities through cheap engravings and lithography. A decade after the Bohn edition of Lodge, the National Portrait Gallery opened in Great George Street, Westminster. Behind its creation lay a formidable array of intellects, and above all the apostles of the role of the great man in the saga of a nation's history: Prince Albert, Lord Stanhope, Carlyle and Macaulay. For three years also, beginning in 1866, a great annual exhibition of historical portraits was held at the South Kensington Museum under the direction of the Portrait Gallery's first director, Sir George Scharf. The exhibitions covered the whole span of time from the fifteenth century down to the reign of Victoria, and for the first time the portraits were photographed. Many of these negatives still exist

in the Victoria & Albert Museum. By 1870, the faces of the past could no longer be interpreted according to the whim of the present. The science of portrait iconography had been born.

When we turn to historical painting, it is during the 1820s, simultaneously with the publication of Lodge, that we find a definite effort by artists at correct historical likeness and genuine portrait research. In 1824 Sir William Allan painted his dramatic portrayal of the abdication of Mary Queen of Scots, carefully basing his portrait of her on a version of the celebrated 'Oudry Portrait'. Bonington, for his picture of Surrey and his mistress, the fair Geraldine, painted in 1825–6, must have drawn on the engraving of the full-length portrait at Hampton Court believed to be of the poet Earl. In 1827 C. R. Leslie undertook careful

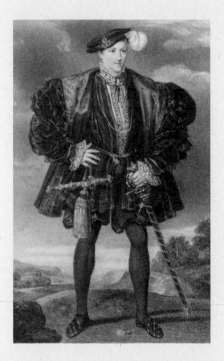

40 and 41. (*Left*) Edward Scriven's engraving entitled *Henry Howard, Earl of Surrey*; (*right*), the very close copy produced by Bonnington in *The Earl of Surrey and the Fair Geraldine* (1825–6).

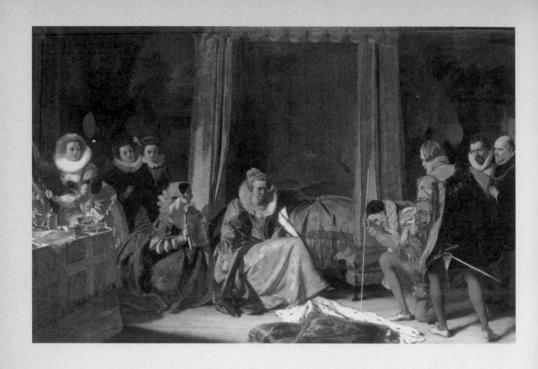

42. (*Above*) Augustus Leopold
Egg, *Queen Elizabeth discovers she
is no longer Young* (1848).
43. (*left*) Detail from William
Larkin's portrait of Anne
Clifford, Countess of Dorset
(*c.* 1610) the source of the left-
hand figure.

research for his *Lady Jane Grey prevailed upon to accept the Crown* (see page 126). The figure of Jane's unpleasant mother is derived from Vertue's engraving of the famous Hans Eworth double portrait then believed to show the Duchess of Suffolk and her last husband, Adrian Stokes. Leslie was also regarded as a major pioneer of accuracy in costume during the twenties: Richard Redgrave, Surveyor of the Queen's Pictures, recorded that 'his dresses at least have the air of truth', and when asked how he achieved this, Leslie replied that he 'made them up from old prints and pictures'.[38] By the thirties and forties the mania was being carried to extremes by artists such as William Fisk, whose trials of Strafford and Charles I boasted about a hundred authentic portraits between them – a phenomenon paralleled by the vast groups in George Hayter's *The Reformed House of Commons* (1833–43) and Maclise's *Meeting of Wellington and Blucher* (*c.* 1858–9). By then artists were moving around and studying independently the portraits on the walls of the great houses of England. An instance of this is Augustus Egg's *Queen Elizabeth discovers she is no longer Young* (1848), a scene set in James I's state bedroom at Knole where the lady-in-waiting to the extreme left has stepped down from a canvas by Larkin of Anne Clifford, Countess of Dorset, now in the Knole ballroom. Of the travails attendant upon portrait research we obtain a glimpse in C. W. Cope's letter of 5 August 1861 to Redgrave, asking for permission to make a sketch of the head of Charles I from a picture at Hampton Court. 'I am told that you are the man who can help me,' writes Cope, and he goes on to inquire whether it would be possible to 'procure a scaffold there to get near the face'.[39] Here speaks the true descendant of Benjamin West and John Singleton Copley!

The Historic Interior and Exterior: Henry Shaw and Others

Costume and portraiture are two ingredients of the visible past; interior decoration is another. Terrible difficulties beset the artist as he attempted, before the advent of museums, to create the *mise en scène* of an earlier age. Many of them dodged the issue altogether by concentrating on architecture, placing their characters in a landscape or resorting to a massive use of draperies. By the 1830s, however, concern about accuracy in furnishings had become as great as concern over historic dress. Until then, as in the case of costume, Strutt had been the pioneer source. His *Manners, Customs, Arms, Habits, etc. of the Inhabitants of England* did include an enormous amount of information on furniture and interiors, which seems to have been used by West, but no handy book of reference devoted entirely to antique furniture appeared until 1836, when the Antiquary Henry Shaw's *Specimens of Ancient Furniture drawn from existing authorities* was published.

This book was a milestone, and the learned introduction written for it by Sir Samuel Rush Meyrick reveals that, like the other manuals, it was specifically designed for use by artists:

> From the want of such a collection, artists of the highest repute have sometimes produced pictures, of which the details are so full of incongruities and anachronisms, as materially detract from the general merit of the piece. In an historical composition, correctness of the auxiliaries is scarcely less important than in the more prominent parts . . . Extreme accuracy, even in the minutest detail, can alone produce that illusion which is requisite for the perfect success of a work of art; everything must be consistent to be complete, and an anachronism in an historical picture is as offensive to the eye of taste as is an imperfect metaphor or a defective verse to the ear.[40]

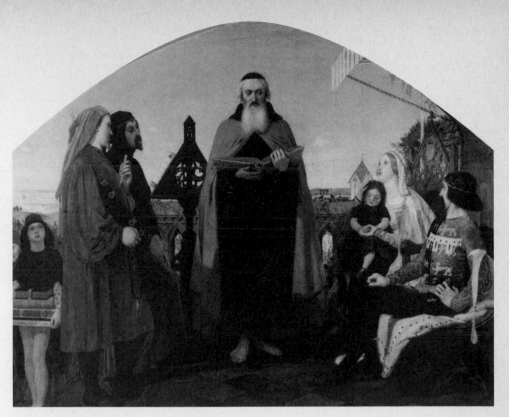

44. Ford Madox Brown, *John Wycliffe reading his Translation of the Bible to John of Gaunt* (*c.* 1847), details of which were undoubtedly inspired by a study of Shaw.

Thus Meyrick enunciates the gospel of the artist-antiquarian. The book, which, it is stated, was designed to complement Planché's work on costume, consists of seventy-four plates covering tables, chairs, sideboards, mirrors, chandeliers, beds, lecterns, firedogs and other impedimenta of bygone households. One plate, for instance, illustrates a chair from Knole House which is actually mid-seventeenth-century in date, although included by Shaw as Jacobean.

Seven years later, Shaw followed this with his *Dresses and Decorations of the Middle Ages* (1843), an extremely lavish expedition into 'the varying changes in dress and fashion' in which coloured engravings of actual artefacts, illuminations from manuscripts, portraits and other sources are welded together to give a highly spectacular impression of medieval life.

95

45. A fifteenth-century canopied chair, illustrated by Henry Shaw in *Specimens of Ancient Furniture drawn from existing authorities* (1836).

46. Shaw's plate of a reading desk.

Whether or not artists actually used these books is almost beside the point. What Shaw's books did was to lay down that, here also, accuracy was to reign supreme. By the 1850s the South Kensington Museum collections were becoming available for study as a source for domestic utensils, and there were also the hundreds of manor houses the length and breadth of England which were believed to have survived 'unchanged', encapsulating the ethos of other eras. It is difficult to find specific instances in which Shaw was definitely used, because the material could have been obtained from other sources. One picture which probably draws on him is Ford Madox Brown's *John Wycliffe reading his Translation of the Bible to John of Gaunt* (*c*. 1847). The lectern could be a combination of the reading desk from Detling church in Kent with the one from Ramsay church in

Huntingdonshire. The Gothic canopied chair to the right could have been inspired by the plate of chairs, stools and beds of the fifteenth century, derived by Shaw from various manuscripts. With Shaw's books on furniture we have suddenly arrived in the modern world of 'antiques', and they had an immediate influence on contemporary furniture design.

Research for authentic furnishings, therefore, became a major preoccupation for artists engaged on historical compositions. The progress of Daniel Maclise's reconstruction of Edward IV's visit to William Caxton at Westminster can be followed in a letter he wrote to his friend John Forster in 1851:

> Caxton's monograms, copied from original all seen pasted against a pillar – a facsimile of a hand bill – preserved in the Bodleian Library at Oxford . . . I was fortunate in getting an old press – which had been in the possession of Jeremy Bentham & worked by him – differing in no respect from the oldest representation in the woodcuts and exactly agreeing with the one in the title-page of a book printed in 1498 by a famous printer, Iodocus Badius Ascensianus.[41]

Maclise's approach to the England of Edward IV makes a dramatic contrast to that of Downman or Opie, sixty years earlier, when they depicted the amorous Edward encountering Elizabeth Woodville.

Parallel with these developments ran the discovery of the architecture of the past. We do not need to linger long over this because it has been the most fully documented of all our fields of study owing to its very real relationship with revivalism in building. Kenneth Clark pioneered the subject in 1928 in his first book, *The Gothic Revival*, but he and the others who have followed have been primarily concerned with reassessing the achievement of Victorian revivalist architects. In other words, the work of the

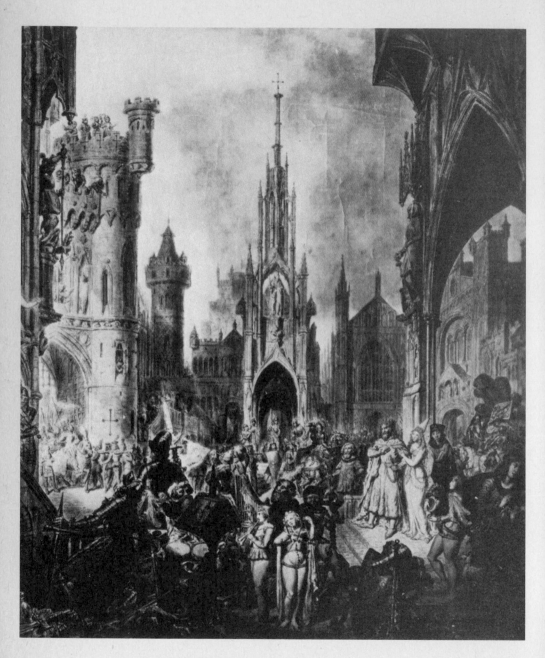

47. John Carter, *The Entry of Prince Frederick into the Castle of Otranto* (1790).

early investigators has been looked at vertically, in terms of its influence on later generations, but never horizontally, in the broad context of its overall relationship to the rediscovery of the past. The pattern it follows is well plotted and reflects exactly that already seen in other fields. A Gothick Picturesque phase, typified by Batty Langley's *Gothick Architecture Improved* of 1742, was followed by an antiquarian phase represented by John Carter's *Ancient Architecture of England* (1795–1814) and John Britton's *Architectural Antiquities of Great Britain* (1805–26) and his *Cathedral Antiquities* series (1814–35). Then came the serious work of the twenties: Pugin's *Specimens of Gothic Architecture* (1820) and Joseph Nash's *A Series of Views Illustrative of Pugin's Examples of Gothic Architecture* (1830). These covered the Middle Ages, with detailed measured drawings, while Tudor and Stuart architecture was soon opened up in T. F. Hunt's *Exemplars of Tudor Architecture* (1830) and similar works by T. H. Clarke and C. T. Richardson.

Of these figures I will take only John Carter (1748–1814) to enlarge our understanding of the impact of antiquarianism on the visual arts in eighteenth- and early-nineteenth-century England. Carter received a grounding in architectural drawing, and at the age of thirty-two was employed as a draughtsman by the Society of Antiquaries. In 1795 he became a Fellow, and his first important work was *Specimens of Ancient Sculpture and Painting* (1780–94), the first volume of which was dedicated to Horace Walpole. Henceforth his preoccupation was to be the exact archaeological recording of Gothic, but a watercolour he executed in 1790, entitled *The Entry of Prince Frederick into the Castle of Otranto*, demonstrates a talent for accurate re-creation of the past far greater than any displayed by the history painters of the Gothick Picturesque in the Academy. Into an amalgamation of real and imaginary Gothic architecture he has inserted a throng of people in medieval dress. The general feeling is that of the late fifteenth century; a king and queen stand to the right, knights in armour with plumes fluttering enter through

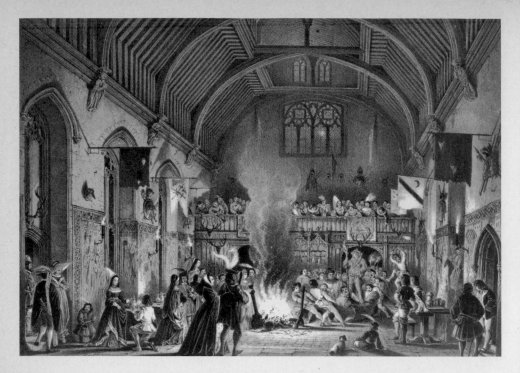

48. The Hall at Penshurst, Kent, as depicted by Joseph Nash in *The Mansions of England in the Olden Time* (1839–49).

a castellated gateway to the left, and trumpeters and musicians are grouped in the foreground.[42] In this composition, significantly, the antiquarian draughtsman has crossed the bridge of the imagination and become an artist.

Antiquarian into Artist: Nash and Cattermole

Useful though all these works of reference were to the painter – as indeed were the actual buildings themselves – one book more than any other had a potent influence on how people wished to see the England of the past. This was Joseph Nash's (1809–78) *The Mansions of England in the Olden Time*, published between 1839 and 1849. It had an enormous success, and ran into several subsequent editions in the course of the century. Through its picturesque re-creation of

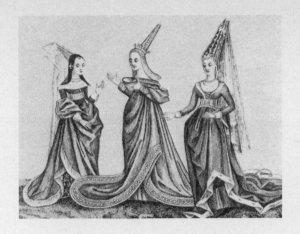

49. Strutt's 'Ladies of the Rank of the 15th and 16th Centuries', from *The Dress and Habits.*

life within a great house, inspired by the Intimate Romantic tradition of Bonington, it cast a powerful spell. The formula which Nash hit upon was a simple one: into not particularly accurate views of medieval, Tudor and Stuart houses he inserted scenes and figures appropriate to the period of the architecture.[43] Perhaps it is no coincidence that this book appeared around the same time as Harrison Ainsworth's *Tower of London* (1840), which employs exactly the same technique in the novel.

The great hall at Penshurst Place is evoked by Nash in its splendour as of old. We are asked to witness the arrival of the Yuletide log (a happening derived from Strutt's *Sports and Pastimes* and symptomatic of Merry England), and the hall is filled with revellers; the huge log is presided over by a man dressed as a medieval wildman; guests lean down from the minstrels' gallery while elegant figures parade in the foreground, ladies in elaborate fifteenth-century trailing gowns and fantastic headdresses attended by gentlemen in equally rich attire. If the figures look a trifle familiar, it is hardly surprising, for they are lifted straight out of Strutt. Nash, of course, states that all his costumes and activities are derived from authentic sources.

In the Long Gallery at Hatfield House, James I and his Queen, Anne of Denmark, stand graciously receiving. Queen Anne is again

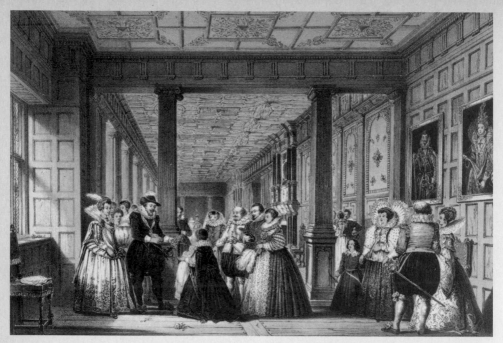

50. The Gallery at Hatfield House as Nash saw it.

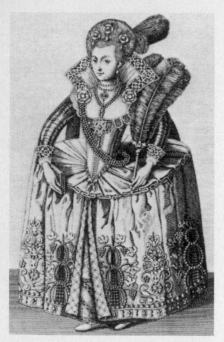

51. Strutt's portrait of Anne of Denmark, from *The Dress and Habits*.

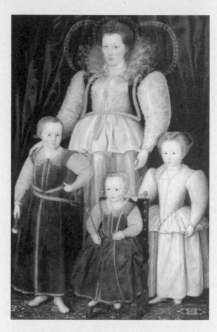

52. Marcus Gheeraerts, *Anne Pope, Lady Wentworth, later Countess of Downe, and her Children* (1596).

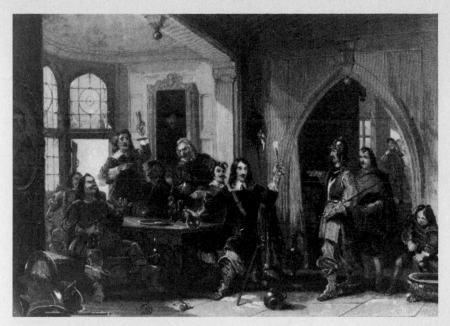

53. George Cattermole, *Goring Carousing* from *The Great Civil War of Charles I and the Parliament* (1841 and 1845).

from Strutt, but the lady and her little boy to the right are taken from a portrait then at Wroxton Abbey of the Countess of Downe and her children. The formula is so brilliant and persuasive that one almost misses the fact that the costumes represented in this animated group stretch over a period of twenty-five years, from 1595 to 1620, and that the chair on the left is definitely not Jacobean. Down the celebrated staircase at Hardwick Hall sweeps a lady wearing a dress of about 1610, based on the portrait that Egg was later to use of the Countess of Dorset at Knole. It would be easy not to notice that she is walking downstairs past tapestries woven many years after her death.

George Cattermole (1800–1868) indulged in similar antiquarian reveries in his works. He was in fact trained by the antiquary John Britton, who encouraged Planché, and contributed to his *Cathedral Antiquities*. A watercolourist and illustrator, he has been categorized as

'the greatest representative, if not the founder, in England of the art that sought its motives in the restoration of bygone times, with their manners and customs, their architecture and costumes, their chivalrous and religious sentiment, complete'.[44] Simultaneously with Nash, he hit on the formula of inserting costume figures, often based on portraits, into carefully reconstructed architectural settings of previous periods. Nothing was to touch Nash's *Mansions*, but Cattermole's *The Great Civil War of Charles I and the Parliament* (two volumes, 1841 and 1845) and *Evenings at Haddon Hall* (1846) contributed greatly in their own way to this visual voyage into times past. And, as in the case of Nash, his debt to Dutch genre painting is patently obvious; *Goring Carousing*, for example, is a straight adaptation of a Netherlandish tavern scene. In *Republican Preaching* he inserts Roundhead soldiers into a compilation of ecclesiastical architecture which could only have been conceived by someone trained as an antiquarian draughtsman.

The last point is important. The background and training of both these artists were utterly different from those of the painters who went through the Academy Schools. Nash was trained by the elder Pugin, and assisted him in his exact drawings of Gothic architecture. Cattermole owed his career to the architectural and topographical antiquary Britton. In other words, one of the strongest forces in the movement to recreate the past came from antiquarian draughtsmen turned artist-illustrators. They had a grounding in the accurate recording of the background to history which could not be paralleled in the training of an academic painter.

Artist into Antiquarian

Cattermole and Joseph Nash were antiquarian draughtsmen turned artist, but of course the process worked both ways. In response to the demand from scholars and public alike that paintings should be an accurate record of time past, the artist himself was progressively

forced to become an antiquarian. We only have to look at pictures or photographs of the interiors of artists' studios in the Victorian period to realize that a revolution had taken place. Instead of being filled with plaster casts after the antique, they are often piled high with old furniture, armour and clothes. Models were dressed up in reproductions of medieval costume. A glance at any of the figure studies, for instance, for Ford Madox Brown's *Chaucer at the Court of Edward III* reveals that it was standard practice in the forties to clothe models in costumes made up according to the illustrations in Strutt, Planché or Fairholt.

A letter from Brown to Lowes Dickinson written during the painting of the earlier version of this picture reads like a shopping list:

> I have been out this evening to procure divers little articles which still remain to be painted in, and have procured a hood of chain mail from Cross, who returned last night from Devonshire, also some feathers to make a fan, and some cloth of gold. Some flowers, a dog, and some white velvet will complete the nasty list of little things to be run after.[45]

Sketchbooks were now constantly filled with drawings of useful antiquarian matter; they became a painter's visual repository for accurate period detail of his own selection. The contents of both studio and sketchbook were fundamental for the methodology of recreating the past.

As accuracy of this kind came within reach through the forties and fifties, it became more and more meaningless and more and more crippling. What had begun as a thrilling adventure, an artistic time machine, had by the third quarter of the nineteenth century become paralysing. A door had been flung open into the past, the artist had entered and had found himself not emancipated but imprisoned. To the generation coming up in the eighties and nineties, it was anathema.

By 1865, the demand on the artist for authenticity of detail was such as to be almost suffocating. In that year Ford Madox Brown looked back over the previous two decades and wrote the critical epitaph on the artist as antiquarian:

. . . twenty years ago, extreme exactness in matters external and archaeological was less in vogue than it is now . . . With me in those days, the dramatic interest in a subject outweighed every other consideration, such was the example set by Delacroix in France . . . set, though not followed.[46]

These views were to be re-echoed even more strongly eight years later by Frederick Leighton as he deliberately abandoned medievalism to pursue classicism:

. . . my growing love for Form made me intolerant of the restraint and exigencies of costume, and led me more and more, and finally, to a class of subjects, or, more accurately, to a set of conditions, in which supreme scope is left to pure artistic qualities, in which no form is imposed upon the artist by the tailor, but in which every form is made obedient to the conception of the design he has in hand.[47]

These words herald the end of that brief brilliant alliance of the artist and the antiquarian, a relationship which was to be relegated by the end of the century to the world of the illustrator and the theatre designer – and, in our own century, the movie spectacular. At its best it had created some of the most stirring and astounding tableaux of our national history, so strong that over a hundred years later we are still unable to visualize them in any other way.

Decline and Eclipse

The heyday was suddenly over, and history was in retreat. How could this vast and exciting expansion in visual imagery have become, within a generation, almost meaningless? The re-creation of the British past in painting belongs to that age when history was still literature for a mass audience, when historians espoused causes with fervour, inviting their readers to take sides, to make moral judgments and to follow the emergence of their nation to its present glory. The climax of this belief might be said to be J. R. Green's best-selling *A Short History of the English People*, published in 1874. This was virtually the last time that serious history was also popular literature.

By 1895, when Acton was appointed Regius Professor of History at Cambridge, everything had changed. Although the scientific study of history had developed earlier on the Continent, and above all in Germany, the home of Niebuhr, Ranke and Burkhardt, it did not reach Britain until the last quarter of the century. Gradually, history became the province of professors and dons and no longer that of men of letters, artists and poets. The educated public came to regard history as a field for scientific inquiry. Historians buried themselves in the critical study of their sources and reacted to the discoveries of Darwin and Spencer. And as this happened, history progressively ceased to be a vehicle of any substance or meaning for the visual arts.

Not only this, but the whole iconography of Victorian painting came under attack. One of the objects of the artists who belonged to the New English Art Club, founded in 1886, was a change of attitude to subject-matter in painting. The late-nineteenth-century rebels, Sickert, Whistler, Sargent, Steer and the rest of them, wanted a reassertion of purely pictorial values in painting and a rejection of the illustrative and anecdotal. In other words, their stylistic statement implied a radically revised iconography in which the Victorian vision of the British past could no longer have any validity or meaning.

More important still than these raps at the door of the establishment was the canker within. We can trace this vividly in G. A. Storey's *Sketches from Memory* (1899), where the artist's sudden realization that he is doing little more than producing meaningless, bogus costume masquerades is vividly recounted. Storey was a member of the St John's Wood Clique, the group foremost in the sixties in promoting these scenes from the past. Here is what he writes about his efforts to compose a picture on the subject of the Lady Arabella Stuart, a favourite doomed heroine of the mid-Victorian age:

> But what did I know about Arabella Stuart and James I., except what Miss Lucy Aikin had told me in her two volumes, and what I could pick up from prints of the period? I got up my accessories just as a stage manager would do for a new piece, borrowed costumes from Nathan & Co. [the theatrical costumiers], and dressed up my model like a pantaloon, to signify the canny King of Scots . . . I tried to imagine William Seymour as a sentimental lover, and to make Arabella pretty, despite her bald forehead and her dreadful farthingale.[1]

This sudden disillusionment was born of a visit to Madrid and a study of Velasquez's *Las Meninas* (1656, Prado) and *The Surrender of Breda* (1634, Prado), and here followed the crucial confession:

In the work of Velasquez I knew that not only were the costumes correct, but the actual men of the time were there before me, the period stamped, not only on the dress, but on every face, in the very attitudes even of the figures; the whole belonging so completely to its own day, even as the hand that wrought it, that I felt I had a true page of history before me, and not a theatrical make-up of a scene dimly realised in the pages of some book written many years after the event.[2]

This passage sounds the death knell of such reconstructions, because in it the artist has finally acknowledged failure. More and more contact with the art of the past, which by 1899 was being made easy by the advent of the half-tone block, must have accentuated the shortcomings of these re-creations and confirmed the total impossibility of their aim. The great adventure had reached its end.

But for almost a century, it had attracted the most brilliant in the world of the arts, and the vision of the British past had been strong and effectual. It is now lost to us, because our eye still tends to be offended by these evocations, which seem on first encounter so shallow and artificial and apparently reduce the painter to the level of a trivial illustrator. But that is where modern critical judgment is wrong. The study of the iconography of Victorian painters is in its infancy. Their historical mythology is just as rich in comment and allusion as their genre paintings of contemporary life, but it requires reading, and we have lost the art. In order to recapture it, we have to take a different path in our pursuit of the Victorian vision of the British past. We have to face up to the irony that the past was only reconstructed in order to speak about the present. And the only way to show this is to unravel the pictures themselves, to study the recreators and their re-creations, to trace their themes and obsessions through the history of Britain, revealing the truth of Buckle's tenet that

there is always 'a connexion between the way in which men contemplate the past, and the way in which they contemplate the present; both views being in fact different forms of the same habits of thought'.[3]

Part Two

THEMES AND OBSESSIONS

Historical subjects require a very great deal of thought and research, which, perhaps, accounts for their having almost disappeared in the present days. I have always considered that the art that can conjure up past events and make them a living reality is something of an achievement, well worth all the pains bestowed upon it.

<div align="right">

Mrs. E. M. Ward

Memories of Ninety Years (1924)

</div>

Reliving the Past

I have already touched upon the periods and personalities which came to haunt the Victorians from their own past, but the time has come now to explore the major ones in far greater detail. Straddled over a century and more, what these inspired make up a disparate group of pictures by artists running from the great to the downright mediocre. How any coherence can be given to such material is a question which might well, at this point, be asked. The approach I have adopted here is to pinpoint one major picture for each obsession or theme and explore it both in terms of contemporary historiography and in those of other works produced during, before and after its inception. Such an approach has the virtue of highlighting pictures which in my estimation can still hold their place on the walls of a public art gallery, although that might be arguable in the case of the one I take as my point of departure, by the painter billed in his time as the English Michelangelo.

Our Forefathers

G. F. Watts's picture of *Alfred inciting the English to resist the Danes* was painted for the 1847 competition for the decoration of the new Houses of Parliament. This was the competition devoted to oil paintings. Watts was studying and working in Italy at the time, and began

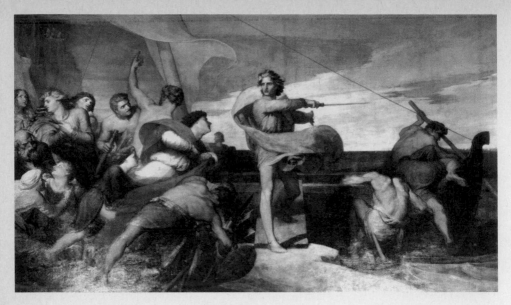

54. G. F. Watts, *Alfred inciting the English to resist the Danes.*

work on the picture in the summer and autumn of 1846, executing
at least two hundred drawings for it and completing it in the April
of the following year in time for shipment to England. In the compe-
tition, the canvas was one of the three which won premiums of
£500, the other two being F. R. Pickersgill's *The Burial of Harold* and
Edward Armitage's *The Battle of Meeanee.* Subsequently, on the
recommendation of Sir Charles Eastlake, the picture was among
those purchased for the walls of the committee rooms of the House,
where it hangs to this day.

The subject-matter Watts had deliberately chosen as being
'dedicated to patriotism and posterity'. He described it in a letter
he wrote to Miss Duff Gordon in December 1846; she had asked
for a detailed account, and this Watts gives, as he states, in the
manner of a showman:

> You ask me to describe my picture of Alfred; the general design
> you are acquainted with. Alfred stands, as you know, in the
> centre of the picture, his foot upon the plank, about to spring
> into the boat. I have endeavoured to give him as much energy,

dignity, and expression as possible, without exaggeration. Long-limbed and springy, he is about the size of the Apollo, the other figures are bigger, so you see my composition is colossal. Near to Alfred is a youth who, in his excitement, rends off his cloak in order to follow his King and leader; by the richness of his dress he evidently belongs to the upper class, and I shall endeavour to make that also evident by the elegance of his form, and the grace of his action. Next to him is a youth who is probably a peasant; he grasps a ponderous axe and threatens extermination to the whole Danish race. Contrasted with him you see the muscular back of an older man, who turns towards his wife, who, with a child in her arms, follows distracted at the thought that her child's father is about to rush into danger. He points upward, and encourages her to trust in the righteousness of the cause and the justice of Heaven (religion and patriotism). Behind him two lovers are taking a hurried and tender leave, and beyond them a maiden with dishevelled locks (your sister's hair), whose lover or father has already departed, with clasped hands is imploring the protection of Heaven. In the corner a youth is buckling on his armour; his old mother, with trembling hands and tearful eyes, hangs about his neck a cross; the father, feeble, and no longer able to fight his country's battles, gives his sword with one hand while with the other he bares his chest, points to his wounds, and exhorts his son not to disgrace his father's name and sword; while with glowing cheek and beating heart the youth responds to his father's exhortations with all the ardour characteristic of his age. This I think is my most interesting group . . . You see I endeavour to preserve a rich base accompaniment of religious and patriotic feeling. A boy, carried away by the general enthusiasm, clenches his little fists, draws his breath, and rushes along with the excited warriors; which helps to indicate the inspiring effect of Alfred's harangue . . .[2]

Watts's choice of the Anglo-Saxons as a vehicle for sentiments rich in 'religious and patriotic feeling' was shared by the historian Lingard. Theirs was the period, in his estimation, 'the most interesting to Englishmen, because it was the cradle of many customs and institutions, which exist among us even at the present day'.[3]

The cult of Alfred can already be found in Hume's *History*, where he appears as a prototype of the Patriot King:

The merit of this prince, both in private and public life, may with advantage be set in opposition to that of any monarch or citizen which the annals of any age or any nation can present us. He seems indeed to be the model of that perfect character, which, under the denomination of a sage man, philosophers have been fond of delineating, rather as a fiction of their imagination, than in hopes of ever seeing it really existing. So happily were they blended; and so powerfully did each prevent the other from exceeding its proper boundaries![4]

Alfred is hailed as 'the Great' and as 'the Founder of the British Monarchy'. In this capacity he appears among the busts in William Kent's Temple of British Worthies at Stowe and in Thomas Arne's stately masque of *Alfred* (1740). In painting he was taken up by Benjamin West in 1779 in his *Alfred the Great divides his Loaf with a Pilgrim*, by Richard Westall in *The Boyhood of King Alfred*, and in the renderings by Francis Wheatley (1792)[5] and David Wilkie (1806)[6] of *Alfred in the Neatherd's Cottage*.

Interest in the Anglo-Saxons apart from Alfred hardly rose above searching the histories for suitable melodramatic sagas, and it was scenes of this sort which first attracted the painters of the Gothick Picturesque. Angelica Kauffmann's *The Interview of King Edgar with Elfrida, after her Marriage to Athelwold*, exhibited in 1771, was the first picture on an Anglo-Saxon theme to be shown at the Royal Academy. Twenty-five years later, John Francis Rigaud essayed the

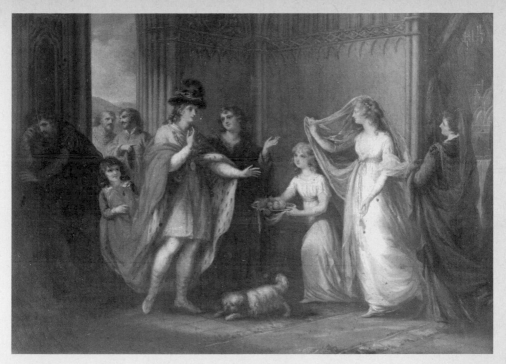

55. John Francis Rigaud, *The first Interview of King Edgar and Elfrida* (1796).

same subject. It is presented in the manner of a scene from a Gothick novel, depicting the moment when the King realizes that his friend has tricked him out of marrying the beautiful Elfrida and married her himself. Such paintings can hardly be said to be reflective of any serious interest in the Anglo-Saxons as a noble race embodying high-minded ideals of liberty and justice. This exaltation of the race really began in earnest in 1799 with the appearance of the first volume of Sharon Turner's *History*, a book which ran into three editions by 1820.[7] Turner was the first historian to attempt a reconstruction of Anglo-Saxon society and its institutions. Through his work the historians of the Victorian age came to view the Anglo-Saxons as exponents of a system of government which was the direct fount of their own representative institutions. Anglo-Saxon England was seen as the ancestor of the monarchically ruled but elected government of nineteenth-century Britain, a burning issue throughout the period of the Reform Acts and the extension of

56. (*Left*) Alfred Stevens, *King Alfred and his Mother* (*c*. 1848).
57. (*Right*) Frederick Richard Pickersgill, *The Burial of Harold* (1847).

the franchise. The Anglo-Saxons were regarded as a freedom-loving, democratic and heroic people, a view woven into literature first by Sir Walter Scott in *Ivanhoe* (1819)[8] and later by Edward Bulwer Lytton in *Harold, the Last of the Saxon Kings* (1848) and Charles Kingsley in *Hereward the Wake* (1866). It was a belief shared by establishment and opposition groups alike. Even Tom Paine's influential *Rights of Man* (1791) subscribes to this view: 'Conquest and tyranny transplanted themselves with William the Conqueror from Normandy into England, and the country is yet disfigured with the marks.'[9] During the sixties and seventies the pedantic middle-class cult of the Anglo-Saxons reached its peak in the infants borne to the font as Eadward and Aelfric.[10] Parallel with this popular dissemination of the idea of the Anglo-Saxons went a scholarly reappraisal which reached its climax in J. M. Kemble's *The Saxons in England* (1849), a book actually dedicated to Queen Victoria. The British people, Kemble writes, have inherited their political institutions 'from a period so distant as to excite our admiration, and have preserved them amidst all vicissitudes with an enlightened will that must command our

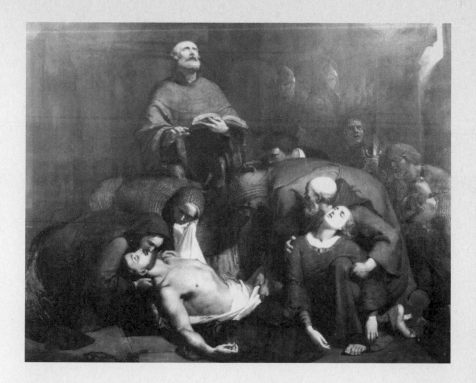

gratitude'. In Kemble's view the Victorians *were* Anglo-Saxons.[11]

The result of all this was a steady flow of works of art celebrating 'our forefathers'. These really began with William Dyce's *St Dunstan separating Edwy and Elgiva* (1839),[12] Richard Dadd's *Alfred the Great reflecting on the Misfortunes of his Country* (1840) and *Elgiva, the Queen of Edwy, in Banishment* (1840),[13] Dyce's *Baptism of St Ethelbert.* (1846), part of the decoration of the south wall of the House of Lords,[14] John Everett Millais's startling *Elgiva* (1847)[15] and Alfred Stevens's *King Alfred and his Mother (c. 1848).*[16] This preoccupation continued into the fifties, notably in Maclise's *Alfred, the Saxon King disguised as a Minstrel in the Tent of Guthrum the Dane* (1852).[17] The mania for the subject of Edith finding the body of the last Saxon king after the Battle of Hastings in 1066 provoked *Punch*, in connection with F. R. Pickersgill's prizewinning picture (based directly on a Lamentation over the Dead Christ), to congratulate the public that

King Harold was buried at last, and to hope that 'British artists would leave off finding his body any more, which they have been doing, in every exhibition, for these fifty years'.[18]

Watts's *Alfred inciting the English to resist the Danes* belongs to the mainstream of this celebration, intensified surely by the nationality of the Prince Consort. The Anglo-Saxons were after all German. No wonder that at the tail end of the cult William Theed should have chosen in 1868 to depict Albert and Victoria as Anglo-Saxons. This astounding tableau could as easily be relabelled 'Alfred the Great and his Queen', so interchangeable had they become.

Victimized Childhood

Alfred the Great is a far cry from the two murdered children of the fifteenth-century Yorkist king, Edward IV. In 1878 that most fashionable of late-Victorian painters, Sir John Everett Millais,[19] exhibited one of his most famous canvases, *The Princes in the Tower*. Millais began this picture on a canvas which he had already painted of the staircase of St Mary's Tower, Birnham, Perthshire.[20] Subsequently, on receiving sketches by his son of the Bloody Tower, he realized that not only was his staircase too small but it was the wrong way round. Millais then conducted his own researches and started again. The Princes were children of professional models, and the artist records his debt to Planché for costume detail, in particular the fact that the King wears the Garter on his left leg.

Millais himself regarded the picture as a companion to his *Princess Elizabeth in Prison at St James's* (1879), another recurring subject for those obsessed with 'the persecution of Royal children, innocent and unoffending, with jealous cruelty'. The earlier canvas, which immediately caught the public imagination, came at the close of a century of interest in the fate of the Princes in the Tower, Edward V and his brother Richard, Duke of York. The artist, drawing on

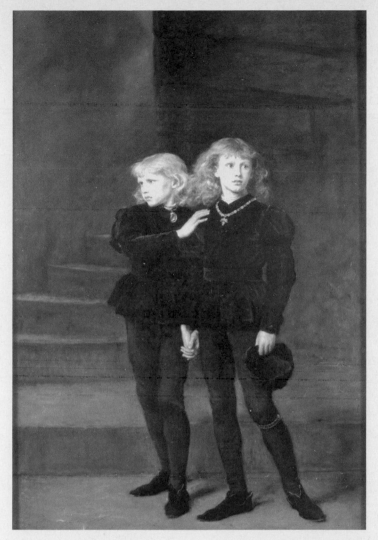

58. Sir John Everett Millais, *The Princes in the Tower* (1828).

this popular mythology, captures brilliantly the terror of these two youths as they sense their impending end at the hands of assassins acting on orders from their uncle, Richard of Gloucester. Although the popularity of the theme inevitably owed much to Shakespeare's *Richard III*, and in particular to bowdlerized versions of it, it also

drew for nourishment on historians who repeated the story as recounted by Sir Thomas More in his life of Richard.[21] Two deeply emotional scenes preoccupied painters: the parting of the young Duke of York from his mother, who had wisely sought sanctuary in Westminster Abbey, and the actual murder of the innocent children. Narratives of the former vary very little from one historian to another, and Hume is as good a source as any. Here he describes Elizabeth Woodville parting from her younger son:

> She was here on a sudden struck with a kind of presage of his future fate: she tenderly took him: she bedewed him with her tears; and bidding him an eternal adieu, delivered him, with many expressions of regret and reluctance, into their custody.[22]

Such a scene of tearful sentiment was an ideal one for painters of the romantic age, and Samuel Wale (1769), John Opie (for Bowyer, 1795), Richard Westall (1800) and E. M. Ward (1842) all essayed it. James Northcote painted for the Boydell Shakespeare Gallery a number of versions of a similarly touching scene, *The Meeting of the two Princes*.[23]

This was complemented by 'a scene truly tragical: the murder of the two young princes', and this Hume recounts as follows:

> The tyrant then sent for Sir James Tyrrel . . . and he ordered Brackenbury (constable of the Tower) to resign to this gentleman the keys and government of the Tower for one night. Tyrrel choosing three associates, Slater, Dighton, and Forest, came in the night-time to the door of the chamber where the princes were lodged; and sending in the assassins, he bade them execute their commission, while he himself staid without. They found the young princes in bed, and fallen into a profound sleep. After suffocating them with the bolster and pillows, they

shewed their naked bodies to Tyrrel, who ordered them to be buried at the foot of the stairs, deep in the ground, under a heap of stones.[24]

Although this subject, and others tangential to it, were dealt with by Opie,[25] Northcote,[26] Thomas Stothard and C. R. Leslie (1830), the two most famous images are those by Delaroche and Millais.

Of these two, Delaroche's conception (1830)[27] is certainly the more powerful. Millais's canvas has the thrill of an episode from a late-Victorian boys' adventure story, but Delaroche's possesses the strength of a reality bred of the French Revolution and the mysterious fate of the Dauphin in the Temple prison. Instead of choosing

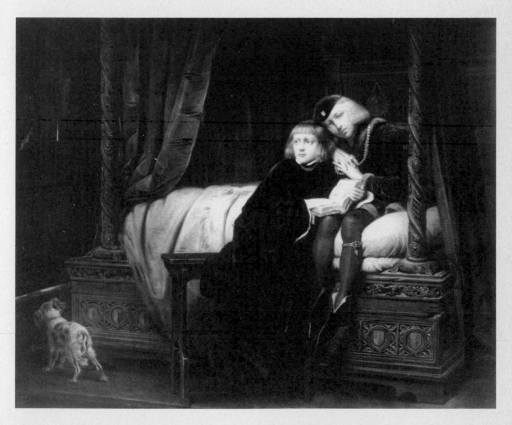

59. Paul Delaroche, *Edward V and the Duke of York in the Tower* (1831).

to depict the actual murder, he moves back in time to an imaginary moment of realization. The Duke of York is reading to his brother the King, who sits on the bed deep in a distant reverie. The younger child has raised his head from his book, and his eyes are filled with fear. A spaniel moves towards the door, beneath which chinks of light and strongly cast shadows suggest incipient action. So compelling is Delaroche's evocation that the viewer never notices that the columns of the bed are inappropriately carved with the Beaufort portcullis and the Tudor rose!

The success of Delaroche's picture was such that the subject was taken up on the Continent by other artists, notably by Hildebrandt in 1835 and P. Miglioretti in 1869. Millais would have seen his subject within this international context, as a direct challenge aiming to supplant in the popular imagination the earlier 'best-selling' canvases on the theme. In order to achieve this he has skilfully married the record of a historical event with another, perhaps even more potent Victorian obsession, the innocence and vulnerability of childhood. As a motif in romantic painting in Britain it can be followed from Reynolds's *The Age of Innocence* (1788) through the genre painters of the 1850s and 1860s to Yeames's *'And When Did You Last See Your Father?'* (1878) and beyond. Millais resorted to it often, most notoriously in another best-seller, *Bubbles*. Whereas Delaroche's canvas holds us in its power as we contemplate the fate of kings, Millais's casts its spell in emotional and psychological terms, through the terror of two young innocent boys – brothers who tenderly clasp hands – as they sense untold terrors in the darkness which encircles them. Millais achieved his aim. His *Princes in the Tower* has retained its place as one of the most popular and enduring of all Victorian evocations of the British past.

The Perfect Lady

Delaroche's handling of the fate of the princes eclipsed any attempt at the subject by British painters. The same can be said of his *The Execution of Lady Jane Grey*. This caused a sensation at the Paris Salon of 1834, when it had already been purchased by Prince Anatole Demidov. On his death, in 1870, it was acquired by an English MP, H. W. Eaton, whose son bequeathed it to the National Gallery.[28] Like Delaroche's other scenes from British history, *The Execution of Lady Jane Grey* had a life and influence totally different on opposite sides of the Channel. For the French, it contained poignant allusions to the horrors of their own immediate revolutionary past; for the mid-Victorians, it joined a stream of paintings and writings which placed Jane Grey among the foremost of their historical heroines.

The picture is, of course, historically inaccurate, for Lady Jane Grey was executed, on 12 February 1554, not in a gloomy Norman hall but outside on a scaffold erected on Tower Green.[29] None the less, this new setting enables Delaroche to surround his fragile heroine with an aureole of saintly light. He is also wrong in showing her helped to the block, to which in fact she resolutely made her own way, although she was attended by two gentlewomen – the ladies who lament to the left in dresses derived from portraits by Holbein of twenty years previously. Although, as Cecil Gould has pointed out, the *livret* of the 1834 Salon refers to a 1588 Protestant Martyrology as the source, this scene could have been created from any reasonable narrative of the event. In spite of all this, Delaroche's re-creation of the drama of the nine-day Queen's execution remains overwhelmingly powerful.

In nineteenth-century England, Jane Grey represented an obsessional female type: the victimized child-woman who as a literary character runs direct from the works of Mrs Radcliffe down to Dickens's Florence Dombey. Interest in Jane Grey, however, had

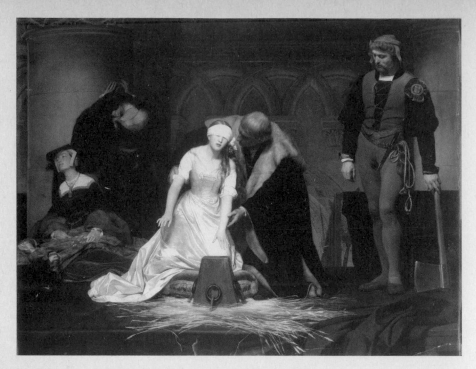

60. Paul Delaroche, *The Execution of Lady Jane Grey* (1834).

61. C. R. Leslie's *Lady Jane Grey prevailed upon to accept the Crown* (1827).

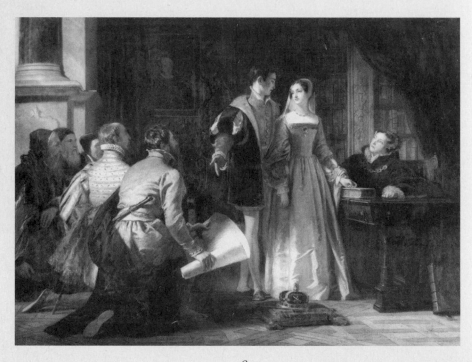

its roots as far back as the sixteenth century, when John Foxe eulogized her in his *Acts and Monuments* – still standard Sunday reading throughout the Victorian age: 'let this worthy lady pass for a saint: and let all great ladies which bear her name imitate her virtues'.[30] Bishop Burnet in 1680 categorized her as one 'so humble, so gentle and pious, that all people both loved and admired her'.[31] In 1715 she was made the subject of a major tragedy by Nicholas Rowe, and by the 1790s could occupy the brush of Northcote (1792), who depicted her for Bowyer's Historic Gallery being subjected to the wiles of Abbot Feckenham, a scene conceived in terms of a tableau from a Gothick horror novel.[32]

Although John Singleton Copley painted *The Offer of the Crown to Lady Jane Grey* in 1806–7 – a picture which owes its compositional formula to an Annunciation[33] – it was not until after 1827 that she became a figure of intense interest to artists, writers and public alike. This phenomenon was to last until the 1870s. The cult was prefaced by C. R. Leslie's influential *Lady Jane Grey prevailed upon to accept the Crown* (1827), painted for the Duke of Bedford five years after the publication of George Howard's *Lady Jane Grey and her Times*.

The scene Leslie depicts is set in Durham House in the Strand on 6 July 1553 when, immediately subsequent to Edward VI's death, the Dukes of Northumberland and Suffolk were sent to Lady Jane Grey to inform her that her cousin had left her the crown. We can take up the story in the words used in the Academy catalogue of 1827:

The Duke of Suffolk, with much solemnity, explained to his daughter the disposition the late King had made of his crown by letters patent . . . and in conclusion, himself and Northumberland fell on their knees, and paid their homage to her as Queen of England. The poor lady, somewhat astonished at their behaviour and discourse, but in no respect moved

by their reasons, or in the least elevated by such unexpected honours, answered them, 'that the laws of the kingdom and natural right standing for the king's sisters, she would beware of burthening her weak conscience with a yoke which did belong to them . . . My liberty is better than the chain you proffer me, with what precious stones soever it be adorned, or what gold soever framed . . . And if you love me in good earnest, you will rather wish me a secure and quiet fortune, though mean, than an exalted condition, exposed to the wind, and followed by some dismal fall.'

All the moving eloquence of this speech had no effect; and the Lady Jane was at length prevailed on, or rather compelled by the exhortations of her father, the intercession of her mother, the artful persuasions of Northumberland, and above all, the earnest desires of her husband whom she tenderly loved, to comply with what was proposed to her.[34]

The text has an iconographical tightness which recalls humanist programmes for Renaissance artists. This is the moment Leslie depicts. Jane, the bluestocking, her hand upon a Bible, receives her father-in-law, Northumberland, and the other great lords, all on their knees, while her husband and ambitious mother entreat her to accept the crown they offer.

Wherever possible, Leslie has based his figures on authentic sources: Frances Brandon, Duchess of Suffolk, Jane's mother, is taken from the notorious double portrait by Hans Eworth then believed to be of her together with her last husband, Adrian Stokes. Jane herself is a free interpretation of the only authentic portrait, an engraving from a series of Protestant heroes and heroines published in 1620 and entitled the *Herwologia*, and John Russell, Earl of Bedford, second from the left, is lifted directly from the portrait still at Woburn Abbey, but reversed, with the bonnet removed from his skullcap. The composition, which is based on a formula of

suppliants interceding with the Virgin or a saint, is orchestrated in the Venetian manner, with heavy overtones of Titian. Instead of the stiff icons of Tudor England, Leslie was trying to paint the event as though it had been recorded by a master of the Renaissance in northern Italy. And, of course, in the breadth of the brushwork and in the drama of the light there is the influence of his friend Constable.

Leslie must have worked, at least in part, from made-up costumes, because the observation here is very direct, in contrast to his total uncertainty as to the architectural structure and decoration of the room. A huge column on the left is impossible to relate in any logical way to the bookshelves behind or to the nondescript drapery to the right. Although one senses a theatrical influence (he was passionately interested in the stage), the picture is more than a mere tableau. It is carefully composed, the faces are animated by the psychological tension of the moment, and the light (as in Delaroche's treatment) is deployed to bathe the heroine in an almost super-natural luminosity.

Between 1827 and 1877, twenty-four paintings in all on Jane Grey were exhibited at the Royal Academy. Their themes ranged from her virtues as the exemplary pupil through her spurning of the glories of a crown to her role as a martyr stoutly defending the faith.[35] All these subjects offered an instant reflection of Victorian conceptions as to feminine sensibility. The nine-day Queen was the perfect *exemplum* for study by the daughters of the middle classes who were educated at home, like their heroine, by a governess.[36] John Callcott Horsley's *Lady Jane Grey and Roger Ascham* (1853), in which he depicts the famous incident when Jane Grey was found reading Plato while the rest of the household hunted (a subject tackled five years before by C. R. Leslie, based on lines in a poem by Samuel Rogers), could be updated to represent any mid-Victorian girl sitting reading with her needlework to hand. The cult owed much to Harrison Ainsworth's colourful dramatization of

Jane's last days in his *Tower of London* (1840), which was brilliantly illustrated by Cruikshank, and to *Little Arthur's History of England*, whose author, Maria Callcott, writing in the 1830s, characterized her life thus: 'Some people would have liked Lady Jane [as Queen], first, because they believed their dear young King Edward had wished her to be Queen; and next, because she was beautiful, virtuous and wise, and, above all, a Protestant . . . She was like him in gentleness, goodness and kindness.'[37] But Jane's final position in the Victorian pantheon of perfect womanhood can be summed up best in the opening lines of Agnes Strickland's biography published in 1868: 'Lady Jane Grey is without exception the most noble character of the Tudor lineage. She was adorned with every attribute that is lovely in domestic life, while her piety, learning, courage and virtue qualified her to give lustre to a crown.'[38]

No canvas by a British painter, however, was to rival the potency of Delaroche's dramatic tableau of execution. Its success is due to the artist's oft-used trick of bringing the main action of the picture almost out of the canvas, directly towards the onlooker. Jane is groping her way towards the spectator, gently guided by the Constable of the Tower, the action accentuated by her movement from darkness to light. This picture, in its monumental scale and its combination of historical detail with startling realism allied to a tinge of sentimentality, set the objectives for the British painters of the past in their own set pieces from the 1840s onwards.

The apotheosis of Lady Jane Grey in terms of Victorian ideals of womanhood is at least in her case explicable. When applied to Mary Queen of Scots the result can at times resemble squaring the circle. This time we can take as our point of departure a canvas by the President of the Royal Scottish Academy, Sir William Allan's *The Murder of Rizzio* (1833).[39]

The subject of Mary Queen of Scots occupied the brush of Sir William Allan[40] for a decade, beginning in 1823 when he exhibited

his *Knox admonishing Mary Queen of Scots*. He followed this in 1824 with *Lord Lindsay compelling Mary to abdicate*, in 1827 with *The Landing of Mary Queen of Scots at Leith, 1561* and finally, in 1833, with his masterpiece in Mariolatry, *The Murder of David Rizzio*. All these paintings bear witness to an intensive study by Allan of the personal and historical background to each event, representing a tremendous advance on the work of the Gothick Picturesque painters. In many ways *The Murder of David Rizzio* is a remarkable achievement within the Artist-Antiquarian tradition.

Rizzio was murdered on 9 March 1566 in Mary's cabinet, a small room next to her bedroom, in Holyroodhouse.[41] Within this tiny cabinet she was supping, attended by Rizzio, the Countess of Argyll, Lord Robert Stewart, Arthur Erskine and others. The murderers were let in by Mary's husband, Lord Darnley, who led them up the private stairway from his own apartments below and in through a doorway behind the tapestry hangings. The moment Allan depicts

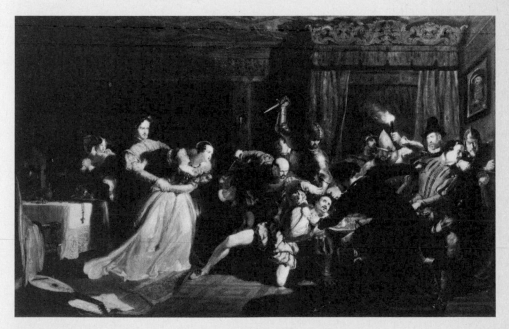

62. Sir William Allan, *The Murder of David Rizzio* (1833).

131

is when Darnley seized his wife and unlocked the grip of the unfortunate Rizzio, who was clinging to her for protection. The luckless secretary was dragged away screaming through her bedroom and savagely butchered to death.

Allan has moved the scene into Mary's bedroom, which he shows as it still survived at the time when the picture was painted. The bed, which is in reality late-seventeenth-century in date, was believed in the nineteenth century to have been the one actually used by the Queen. To the extreme left, the door through which the murderers entered is still open; the table where the party has been dining is to the left; the Countess of Argyll and Mary Seton hide behind Darnley, who prevents the agonized Queen from helping Rizzio. All the murderers are identified: Kerr of Fawdonside with his back to the spectator, Patrick Murray of Tippermuir dragging Rizzio by the cloak, the Earl of Morton pointing towards the door with his sword, and the Earl of Lindsay next to him lifting the green curtain; behind the torchbearer is the Master of Ruthven, his dagger raised to strike, while George Douglas grasps the pathetic Rizzio by the arm. Allan has included Ruthven in complete armour, as he is described in all the contemporary narratives of the murder, ghastly and pale after rising from a bed of incurable disease to wreak vengeance.

The picture is remarkably accurate in costume and portrait detail, and stylistically owes much to Opie, who had painted the same scene in 1787. Allan's earliest work, we know, was in the manner of Opie, but there is also a debt to the domestic interiors by his Scottish contemporary Wilkie. In this painting we see the extraordinary fusion of a dramatic scene in sharp chiaroscuro which, through Opie, goes back to gloomy martyrdoms by early-seventeenth-century Bolognese masters, with the small scale and trailing silks of a type of domestic interior going back, via Wilkie, to seventeenth-century Holland.

By 1833, when Allan painted this scene, Mary Queen of Scots

had already emerged as *the* heroine above every other from the British past. She was cast in the right mould for the romantic age: she was young, beautiful and accomplished; she was subjected to barbarism, scenes of murder, rape, imprisonment and, finally, execution. In her own age she had been viewed as something far different – precisely what depended on one's religious convictions[42] – and the century which followed evinced virtually no interest in the Queen of Scots at all. Interest began in the second decade of the eighteenth century among historians with the opening of a never-ending wrangle as to the authenticity or otherwise of the Casket Letters, which resulted in Mary becoming widely known as a controversial figure.[43] In 1760 Dr Johnson published a vindi- cation of the Stuarts, and five years later his biographer, James Boswell, commissioned Gavin Hamilton, the leading exponent of the neoclassical style in the 1760s, to paint *Mary Queen of Scots resigning her Crown* (see page 11). Hamilton's composition, which was painted in Italy and eventually exhibited at the Royal Academy in 1776, represents the beginning of the public cult of the Queen of Scots. Like Copley and West, Hamilton was an artist-antiquar- ian, and the portrait of Mary, as mentioned earlier, is carefully composed from a miniature then believed to represent her. The formula for the picture is directly based on the iconography of Christ before Pilate.[44]

Between 1786 and 1798 a dozen paintings appeared on the walls of the Royal Academy, all in the Gothick Picturesque vein, on the subject of Mary. They reflect the changed attitude to the Queen as expounded by her partisans, portraying her as a beautiful, tragic heroine caught in the midst of a web of appalling violence and intrigue. The two most important canvases were those by John Opie, *The Execution of the Queen of Scots* and *The Death of Rizzio* (1787). The *Execution*, painted for Bowyer's Historic Gallery, makes no attempt at reportage or historical accuracy, and the Queen could just as well be Marie Antoinette, whose execution must anyway

63. Skelton after John Opie,
*The Execution of Mary Queen of
Scots* (1795).

have greatly accelerated public interest in previous queens who died
on the scaffold.[45]

The prime image of the romantic Mary, however, stems from
the novels of Sir Walter Scott. Scott dealt with sixteenth-century
Scottish history in two novels, *The Monastery; A Romance* and its sequel
The Abbot, both of which appeared in 1820. The period covered was
from the Battle of Pinkie in 1547 to the Battle of Langside in 1568;
The Abbot centres on Mary's imprisonment in Lochleven Castle, her
escape and her subsequent defeat and flight into England.[46] The
theme of the two novels is that of a society in conflict, both sides
of which in the end seem to be discredited, and the story ends on
the threshold of the Elizabethan peace which Scott moved on to
deal with in *Kenilworth*, published the following year. The hero of

The Abbot, Roland, although he begins as a Catholic and a supporter of Mary, ends by becoming a Protestant and marrying Mary Seton. Mary Queen of Scots is glorified as the romantic heroine of a lost cause, the representative of a passionate world dependent on chivalric loyalty which was to vanish for ever with her own person.

Shortly after the publication of these novels, the first of a whole series of biographies of Mary started to appear. These began in 1822 with the first properly documented account, George Chalmers's *The Life of Mary, Queen of Scots*. Chalmers was moved to write about her because he felt that she was 'a calumniated woman, and an injured princess' who lived in corrupt times. The state papers were ransacked to establish the innocency and virtues of this Queen.[47] The correspondence between Allan's subject-matter and the works of Scott and Chalmers cannot be coincidental. Allan, in his painting of scenes from the life of the Queen of Scots, was giving visual expression to this vision of ideal womanhood. 'Who is there', wrote Scott, who knew Allan,[48] 'that, at the very mention of Mary Stewart's name, has not her countenance before him . . . a countenance, the like of which we know not to have existed in any other character moving in that high class of life.'[49] Allan's creations of the delicate, romantic Mary contributed to her gradual assumption of the role that she was to occupy by the 1840s – that of forerunner of the perfect Victorian gentlewoman.

These paintings heralded an intense interest in the Queen of Scots for the rest of the century. Between 1820 and 1897, fifty-six works on this theme were exhibited at the Royal Academy, and these were just the top of a more sizeable iceberg. In addition, the cult proliferated through thousands of engravings after contemporary portraits and reconstructions of incidents from her life. The subjects of the Academy works, broken down as far as the information allows, were as follows: six of Mary's abdication at Lochleven Castle, six of the murder of Rizzio, seven of encounters with Knox, six of her in captivity, four of scenes connected with her escape

from Lochleven, two of her execution, and four each of the Battle of Langside and her farewell to France.[50]

In 1834 Wilkie first began to be intrigued by the subject of the Queen of Scots. His drawing of her being shown the infant James VI[51] utilized the formula of a Virgin and Child, and later he painted the Queen's escape from Lochleven Castle (1837).[52] The two most important canvases from the forties were Frith's *Knox reproving Mary Queen of Scots* (1844),[53] in which the beautiful young Queen sobs at the upbraiding delivered to her, and Ford Madox Brown's *The*

64. Ford Madox Brown, *The Execution of the Queen of Scots* (1841).

Execution of the Queen of Scots,[54] which he began in 1840. During the fifties and sixties she almost became an industry: Joseph Severn's *Mary Queen of Scots at Lochleven Castle* (1850), Frith's *Queen Mary's Last Look at France* (1852) and Herdman's *Execution of Mary Queen of Scots* (1867) are just a few from the vast outpouring on the troubles of this sixteenth-century Scottish Queen.

The Victorian painter, of course, essentially utilized women to stimulate the viewer's sentiments rather than his senses. Sensuality (*pace* Etty and William Frost) was supressed in favour of story-telling scenes extolling woman's virtues as a wife, home-maker and mother,[55] and it was into this mould of the 'perfect lady' that Mary Queen of Scots was surprisingly poured. It was a new idea whose formulation had begun at the close of the previous century. One of the basic evidences of sensibility in a lady was tears. As the lower classes were regarded as cloddish and incapable of expressing sensitivity, the middle and upper classes found in tears a vehicle to reflect their refined delicacy of emotion. Tears flow abundantly from the eyes of heroines from the middle of the eighteenth century onwards. Mrs Ann Radcliffe, author of *The Mysteries of Udolpho*, portrays the weeping, sentimental heroine at full length in her novels of the 1780s and 1790s. She is frequently 'overcome by a faintness', and retires to her chamber, usually unable to eat. In spite of resolving in dire circumstances not to weep, 'her resolution yields to excess of grief'. Indeed, her chief pleasure is to weep in solitude where no one can see. Appalling afflictions reduce her almost to the point of death, but these woes only 'soften to melancholy'. A lute is to hand, which she 'touches with a fine melancholy expression which comes from the heart'. She is rarely too agitated to find time to compose a sonnet or verse on some aspect of her troubles, though she is so delicate that the least puff of wind would extinguish her. Variants of this type of heroine had an enormous vitality for some decades, culminating in the females of the 1840s and 1850s whose passivity in the midst of their travails was such that they reached a hitherto

65. Robert Herdman, *The Execution of Mary Queen of Scots* (1867).

unbelievable extreme of ignorance, innocence and often downright dimness.

It is hardly surprising that the rise in the cult of Mary Queen of Scots coincided with the advent of this type of heroine in the Gothick novel. Buckets of tears flowed from the eyes of Mary Queen of Scots, instantly winning her the applause of all her many biographers in the nineteenth century. She sobbed as she sailed away from France, she burst into tears when upbraided by John Knox, she wept every day after her marriage to Bothwell, she wept when she abdicated, torrents flowed during her imprisonment in Lochleven Castle. Tears fell as she crossed from Scotland to England, they continued to flood down the years of imprisonment in England, and from the moment of the reading of the death warrant to her final execution we are afloat in an ocean of tears. No female character in British history bore such a close relationship to those sensitive ideals of upper-middle-class feeling as did the Queen of Scots.

These, of course, are the moments which we have seen every artist choose to celebrate.

When the sails were set, and her galley began to get out to sea, Mary's tears flowed without intermission. Leaning both her arms on the gallery of the vessel, she turned her eyes on the shore she was leaving with longing, lingering looks, crying at every stroke of the oars, 'Adieu, France! Beloved France, adieu!' And thus she remained . . . motionless as a statue, and deaf to all the attempts of her friends to comfort or divert the sad current of her thoughts . . . When darkness approached, she was entreated to descend into the state cabin . . . and partake of supper. But her heart was too full of grief to permit her to taste food.[56]

So runs Agnes Strickland's account. Tears and inability to take food because overcome by emotion are attributes of the sentimental heroine. This is what Frith, Herdman and their contemporaries were placing before the eyes of their audience: an example of genteel, aristocratic sensitivity.

More even than this, pictures of Mary Queen of Scots are evidence of and comments upon the position of women in Victorian society. Mary fitted the bill only ambiguously, for although she was built up as a monument to the female virtues and as an instance of the inability of women to exert power and rule, there was always the lingering possibility that perhaps her defamers were right. Any defence of her virtues necessitated an examination of the evidence for her vices – a dabbling into rape, sexual violence and outright murder. And this double image may have considerably increased her potency as a symbol to the suppressed womanhood of mid-Victorian England.

The Lessons of Revolution

If Victorian womanhood had an ambiguous dialogue in the person of the Queen of Scots, the obession with the Civil War and its chief actors provided a similar vehicle reflecting contemporary political and social issues in an age which witnessed a dramatic extension of the franchise to entirely new classes. In the Royal Academy of 1878 the almost forgotten Victorian painter, William Frederick Yeames[57] exhibited what was destined to become one of the most famous of all Victorian evocations of the British past, *'And When Did You Last See Your Father?'* [58] So celebrated did this picture become that it was translated into a wax tableau in Madame Tussaud's, where it stands to this day. Yeames's achievement lay in crystallizing for all time in one potent image the whole saga of romantic, doomed Cavaliers and stern, relentless Puritans, a subject which occupied a central position amongst the themes and obsessions of the Victorian literary and artistic mind. The child, a figure clearly derived from Gainsborough's *Blue Boy*, stands on a footstool about to answer an inquiry made by the Puritan who leans across the

66. William Frederick Yeames, *'And When Did You Last See Your Father?'* (1878).

table towards him. The latter is wanting to discover the where-abouts of the boy's father. To the left the ladies of the house, dressed in elegant Van Dyck silks, cling to each other in tearful emotion. They, it is clear, have not answered the dread question. We, the viewers, are held for all time in suspense at this poignant moment when an innocent child might inadvertently betray his father through his own truthfulness. '*And When Did You Last See Your Father?*', like all Victorian narrative paintings, leaves us to fill in what has gone before and speculate as to what might happen after in a highly tantalizing way.

But why should this scene of confrontation and moral dilemma be set in the England of the Civil War? Yeames's painting is perhaps the sole survivor in the popular imagination of almost fifty years' preoccupation on the part of historians, novelists and artists with the second quarter of the seventeenth century. More works of art were produced depicting scenes connected with Charles I, Oliver Cromwell, Henrietta Maria and the struggle of Cavalier versus Roundhead than for any other period of British history. Yeames's picture came at the tail end of this explosion. On the surface of it, few periods should have been less appealing to High Victorian ideals than that of Caroline and Cromwellian England. Indeed, at first glance the two worlds seem diametrically opposed. As in the case of Mary Queen of Scots, the explanation for this particular obsession is rather complex, and we have to reconnoitre back in time to find out why it should have provided such a rich vehicle for the Victorian imagination.

We begin with John Singleton Copley's *Charles I demanding in the House of Commons the Five Impeached Members* (see page 34), a milestone in historical re-creation and a visual microcosm of eighteenth-century attitudes – ones which the nineteenth century was to inherit and expand.[59]

Although Copley's picture was not exhibited until 1795, it was begun fourteen years earlier. Why should this incident, when

Charles I went to the House in an attempt to arrest five of its Members, have inspired a major historical composition? David Hume introduces his narrative of the event with these words: 'A few days after, the King was betrayed into another indiscretion, much more fatal; an indiscretion to which all the ensuing disorders and civil wars ought immediately and directly to be ascribed. This was the impeachment of Lord Kimbolton and the five members.'[60] In other words, this incursion into the House was seen to precipitate the final outbreak of Civil War in 1642.

Our view of the War has been formed by the historians of our own day, by R. H. Tawney, Hugh Trevor-Roper and C. V. Wedgwood, and, in a previous generation, by Gardiner and Ranke. To understand Copley's canvas we have to grasp the entirely different significance which the world of the Enlightenment attached to this clash of King and Parliament.[61] These views were inevitably coloured according to whether one was Whig or Tory, but both parties believed that the present system of government in England reflected traditional English 'liberties' fought for and won in the struggle of King and Parliament, a mode of constitutional government set against Continental and especially French 'slavery'. For the Whig historians and propagandists, for patriotic Englishmen and for Continental Anglophiles, England's unique democracy was a source of pride. She alone had maintained and renewed the ancient liberties which freedom-loving invaders had first brought from the forests of Germany to oppose the autocratic might of the Roman Empire. These ancient liberties had always abided until the pretensions of kingship by divine right propagated by the first two Stuart kings had threatened to violate them. So ran the classic Whig scenario. Seen through the eyes of Hume, this canvas celebrates the defence of English liberty:

> A sergeant at arms, in the king's name, demanded of the house
> the five members; and was sent back without any positive

142

answer. Messengers were employed to search for them and arrest them. Their trunks, chambers, and studies, were sealed and locked. The house voted all these acts of violence to be breaches of privilege, and commanded everyone to defend the liberty of the members. The King, irritated by all this opposition, resolved next day to come in person to the house, with an intention to demand, perhaps seize in their presence, the persons whom he had accused.[62]

We start, therefore, with the confrontation of Roundhead and Cavalier as a constitutional one. The haze of glamorous romance distilled by Yeames a century later did not exist in 1795.

Interest in the Civil War was not renewed until after the close of the Napoleonic Wars, and this time it sprang from a new impulse, the romanticism of Sir Walter Scott. The struggle of Charles I and Cromwell, of Cavaliers and Roundheads, a subject rich in local legend and folklore, was ideal material for the pen of Scott. He treated the Civil War twice, first in 1813 in *Rokeby* and later, in 1826, in *Woodstock; or, The Cavalier. A tale of the year sixteen hundred and fifty-one.* In these, for the first time, the combatants were projected as people of heroic romance.

Rokeby is a narrative poem set in the aftermath of the Battle of Marston Moor. It is dominated by the hostility of Cavaliers and Puritans and deals with the claims of love across such ideological barriers. Loyalty to the King, filial obedience and the demands of rank are inextricably intertwined. But it was not until *Woodstock* that Scott successfully analysed the motivation behind such divisions through the carefully drawn characters of the old Royalist Sir Henry Lee, the moderate Parliamentarian Markham Everard, the dissolute Cavalier Wildrake and the Puritan fanatics Desborough and Harrison.[63] In *Woodstock* Charles I became the perfect aristocrat of the *ancien régime*, a prime exponent of enlightened paternalism and *noblesse oblige*:

. . . if moral virtue and religious faith were to be selected as the qualities which merited a crown, no man could plead the possession of them in a higher or more indisputable degree. Temperate, wise, and frugal, yet munificent in rewarding merit – a friend to letters and the muses, but a severe discourager of the misuse of such gifts – a worthy gentleman – a kind master – the best friend, the best father, the best christian.[64]

So Scott describes Charles through the lips of Alice Lee, the old Royalist's daughter. One can see the Victorian Charles taking shape, the ideal paterfamilias, a tragic symbol of vanishing monarchic and aristocratic society. The Scott vision of noble and loyal Cavaliers is the one which will lead us down to Yeames's 'And When Did You Last See Your Father?'

The Victorian celebration of Charles I as ideal husband and father found its most compelling visual expression in Daniel Maclise's *An Interview between Charles I and Oliver Cromwell (c.* 1836), in which the sad-faced King listens to his son reading while a spaniel, hugged by his daughter, sits on his lap and a hound rests its chin on the royal knee. Oliver Cromwell, in stark contrast, attracts neither children nor animals but sits in gloomy, threatening solitude.[65] A similar vision is Frederick Goodall's lyrical *An Episode of the Happier Days of Charles I* (1853; see page 51), in which the King, his wife and adorable children sail down the river on a summer's day. In Charles I and his family the viewers were surely meant to be looking at the historical prototype of the middle-class domestic happiness (feeding the swans) of their own Victoria and Albert.

In the aftermath of Scott the Civil War enjoyed a sustained vogue as a background for historical novels and plays.[66] The same year that *Woodstock* was published Horace Smith produced *Brambletye House; or Cavaliers and Roundbeads*, a romance also set in the years of the Protectorate. In 1837 G. P. R. James wrote *Henry Masterton; young Cavalier* and Browning in his play *Strafford* described Charles I as

'the man with the mild voice and the mournful eyes'. Shelley had begun a play about Charles I as long ago as 1818, but left it unfinished. Tragedies were, however, written by E. Cobham in 1828, by Mary Russell Mitford in 1840 and the Rev. A. T. Gurney in 1846. This obsession within the theatre was to find its most enduring form in Vincenzo Bellini's light-hearted opera *I Puritani di Scozia*, based on the play *Têtes Rondes et Cavaliers* by François Ancelot and Xavier Boniface Saintine.

The latter had its début at the Théâtre Italien in Paris in 1835, reflecting a similar French preoccupation with the personalities and events of Stuart England. This had begun in 1818 with Balzac's play on Charles I and Cromwell, which was followed by Villemain's *Histoire de Cromwell* (1819). In 1826 Victor Hugo began his famous *Cromwell* and in 1826–7 Guizot published his influential *Histoire de la Révolution d'Angleterre*, translated into English in 1845 by William

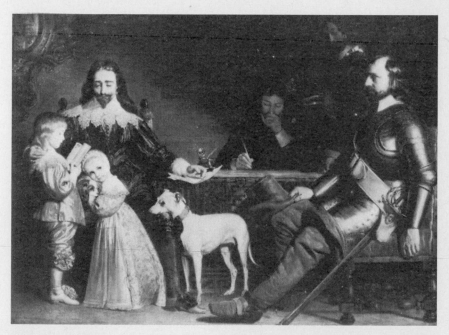

67. Daniel Maclise, *An Interview between Charles I and Oliver Cromwell* (c. 1836).

Hazlitt. The French interpretation of the Civil War strengthened and influenced the Victorian. Guizot believed that it was a precursor of the French Revolution of 1789: 'They struggled for liberty against absolute power, for equality against privilege, for progressive and general interests . . . the first would never have been thoroughly understood had not the second taken place.'[67] The French interest in the Great Rebellion was from the start essentially a political one, a historical autopsy on the Revolution. Along with this they did, of course, derive from the translation of Walter Scott's works the haze of romantic melodrama which attended any saga of Cavaliers and Puritans.

As in the case of Lady Jane Grey, Paul Delaroche occupied a key position in the new mythology. He painted no less than three major canvases on the subject of the English Civil War: *Cromwell gazing at the body of Charles I* (1831; see page 56), *The Mocking of Charles I* (1837) and *Strafford on his Way to Execution* (1837). The first of these was subsequently exhibited at the Royal Academy in London, while the second was purchased by the Earl of Ellesmere; all three were subjects for best-selling prints. Delaroche always denied that his pictures had any explicit contemporary reference, maintaining that they were merely scenes of noble suffering and heroism from the past, but surely they could never have been painted without the French interest in the Great Rebellion. Charles I explained Louis XVI, just as Cromwell accounted for the phenomenon of Napoleon. Cromwell looks down on the corpse of Charles I like a figure mourning over the dead Christ. In *The Mocking of Charles I* the Cromwellian soldiers jeer at the King in a direct parody of the mocking of Christ. In such images, which drew upon the most potent emotions within the make-up of the nineteenth-century mind, powerful statements were implicit on the nature and abuse of power, on social change and revolution and their dire consequences. In England these canvases were widely admired, but the images were read, like those of Lady Jane Grey, within a very different historiographical context.

68. Paul Delaroche, *The Mocking of Charles I* (1837).

69. Charles West Cope, *The Burial of Charles I* (1857).

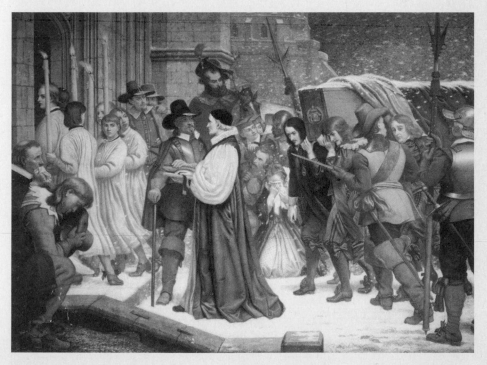

Within the prototypes of Cromwell and Charles and of Cavaliers and Puritans the Victorians had their vehicle *par excellence* for living out their own dilemmas, the dilemmas they faced as the middle classes gradually won ascendancy and power passed to them from the old landed gentry, as radical and revolutionary movements such as Chartism rose to threaten the established social hierarchy, as the new self-made upper classes born of the purple of commerce and manufacture fought for acceptance in the closed world of the old nobility and county families. Between about 1820 and 1900, something like a hundred and seventy-five paintings appeared on the walls of the Royal Academy connected with Charles I and his family, Oliver Cromwell and the Civil War. No other period could match this for intensity of public interest.

We see this preoccupation at its finest in the great series of paintings by C. W. Cope commissioned for the Peers' Corridor in the new Houses of Parliament and executed during the 1850s and 1860s.[68] These monumental paintings, much maligned and victims of wretched experiments in medium, are supreme achievements of the Victorian vision of the British past, brilliant re-creations of lost moments in time within the Artist-Antiquarian tradition. They unfold the whole saga: Charles I demanding the arrest of the five Members (1866), the King raising his standard at Nottingham (1861), the setting off of the train-bands from London to Gloucester (1865), the siege of Basing House (1862), the expulsion of the Fellows of an Oxford College (1865) and the burial of Charles I at Windsor (1857). To these we can add the endless canvases on every conceivable battle and event in the period by A. C. Gow, J. S. Lucas, T. F. Marshall, Ernest Crofts, Augustus Egg or John Gilbert exhibited year by year at the Academy. So obsessive was the interest that a painter like Crofts rarely produced anything else except Civil War battle scenes. He almost lived in the 1640s.

What was the basis for this obsession, and how did it differ from that of the previous century? Until the publication of S. R.

Gardiner's magisterial history in the sixties, the Victorian view of the significance of these events can best be approached through the work of Henry Hallam, and in particular his *Constitutional History of England* (1827), which became a standard work. Hallam followed the eighteenth century in his cult of the British Constitution and of ancient liberties defended. To him as a Whig historian, history was the handmaid of politics and a subject which invited its readers not, as we do today, to stand aside but, on the contrary, to take sides and pass judgment. When he describes the outbreak of the Civil War, he asks 'whether a thoroughly upright and enlightened man would rather have listed under the royal or parliamentary standard'.[69] For Hallam, the upright and virtuous man of the seventeenth century was no different from the same being in his own age, and history was there for morals to be drawn. For him the period's fascination and importance lay in this birth of the Constitution. Writing of this special British glory in an earlier book, his *Europe during the Middle Ages*, he states:

> No unbiased observer, who derives pleasure from the welfare of his species, can fail to consider the long and uninterrupt-edly increasing prosperity of England as the most beautiful phenomenon in the history of mankind. Climates more propitious may impart more largely the mere enjoyments of existence; but in no other region have the benefits that political institutions can confer been diffused over so extended a popu-lation nor have any people so well reconciled the discordant elements of wealth, order, and liberty . . .[70]

All over Europe in Hallam's day the British Constitution was studied as a model to be followed, as Britain alone had escaped the woes of revolution and revolt which still continued to convulse the main-land. Henry Hallam served on the commission for the decoration of the Houses of Parliament from 1841 until his death in 1859. It

is his view of history which enables us to understand the choice of historical subject-matter and its placing within the House. Walking down the Peers' Corridor past scenes of violent conflict gave the Victorian no feeling of unease, for these scenes reflected battles for basic liberties won long ago and inspired a calm confidence in the destiny of this island and its ideal parliamentary democracy.

This, then, was the central idea which animated the Victorian preoccupation with the seventeenth century. But it could also be reversed; the seventeenth century could be seen as a mirror in time of present conflicts, manifested in the meeting of Charles I and Cromwell or Cavalier face to face with Puritan. Many of these tableaux invite the onlooker to read the scene in a variety of ways. They deliberately present the dilemma and leave us the agonizing choice between two worlds. One of the most famous of these is William Shakespeare Burton's *A Wounded Cavalier*, which caused a sensation at the Royal Academy in 1856. Painted under heavy Pre-Raphaelite influence, it is now the only painting by which Burton is remembered. In it a Puritan girl comes to the aid of a Royalist, while her husband or brother (it is not clear which), Bible in hand, stands unmoved. John Everett Millais's *The Proscribed Royalist, 1651* (1853),[71] in which a young Puritan girl gives succour to a Cavalier in hiding, reiterates exactly the same theme, though less successfully. So too does the picture with which we started our pursuit of Cavaliers and Roundheads, *'And When Did You Last See Your Father?'* Yeames, when he wrote of how he had come to paint the picture, gave no clues as to the tradition on which he was drawing and which, if taken away, would irretrievably diminish the impact. All he wrote was as follows:

I had, at the time I painted the picture, living in my house a nephew of an innocent and truthful disposition, and it occurred to me to represent him in a situation where the child's outspokenness and unconsciousness would lead to disastrous conse-

quences, and a scene in a country house occupied by the Puritans during the Rebellion in England suited my purpose.[72]

By 1878 the theme of Cavaliers and Roundheads had been reduced to what seems to us little more than an episode from a children's adventure story. In this painting we catch the dying echoes of one of the most potent of all themes in Victorian painting, a vehicle by which artists had been able to express some of the central ideals and contradictions of their own age.

Four years before Ford Madox Brown[73] had completed his *St Ives, AD 1630. Cromwell on his Farm*. Ford is best remembered today for

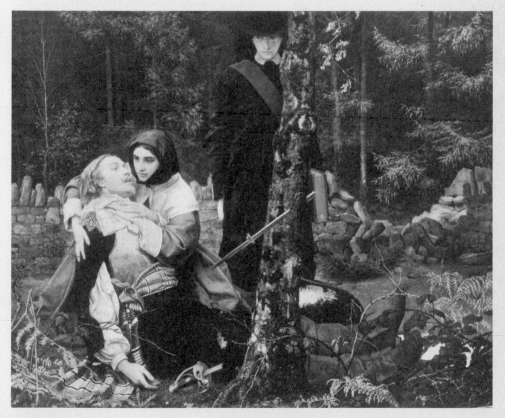

70. William Shakespeare Burton, *A Wounded Cavalier* (1856).

his two most celebrated paintings, *The Last of England* and *Work*, both charged with complex resonances. But what about *St Ives, AD 1630*? This was commissioned by Mr Brockbank of Manchester in 1872, and Ford Madox Brown completed it by March 1874.[74] The description by Forbes Robertson, Senior is worth quoting because it was inspired by the artist himself:

> On a white horse, which grazes leisurely by the roadside before us, sits a stalwart man of saturnine visage, in the prime of lusty manhood.
>
> He is attired in the sober costume worn by thoughtful men in the early part of Charles I's reign, is booted in buff, and his beaver is slouched . . . Before him burns a heap of weeds and stubble, which those two labourers have grubbed from the hedges they have been trimming, and it is the flames thereof that have arrested the attention of their master, and on which he now gazes so earnestly yet so absently.
>
> In vain may the buxom wench, sent by her mistress, who stands with her two children by the garden terrace in front of the goodly manor-house yonder to the right, raise her voice . . . to tell the master that dinner waits.
>
> He hears, and heeds her no more than the little lamb does that nibbles contentedly the herbage by the horse's nose, or than the pig that fancies something good is going on in her neighbourhood, and comes scampering up, with her squeaking litter, among the very horse's feet.
>
> By the consenting fall of the lines of the mouth and the weird speculation in those eyes, he of the white horse sits evidently spell-bound; and that which fixes him is no fairy dance, no pleasing phantasy, but the soul-sobering vision of the prophet or seer.
>
> We have seen where we are in time; but where are we in place, and who is he? . . .

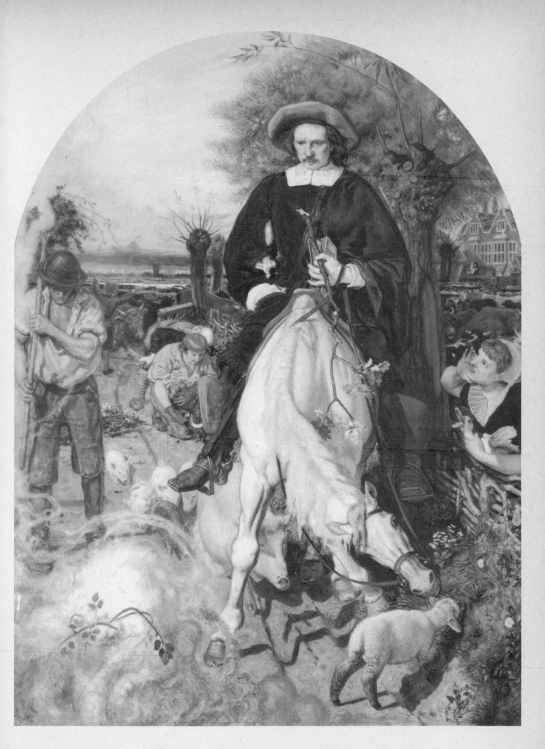

71. Ford Madox Brown, *St Ives, AD 1630. Cromwell on his Farm.*

153

As it is, we are standing on the lands of the Manor of Sleep Hall; all these, to the river side, are its meadows, used, as we see, for grazing purposes, and yonder lady, with her two children, is its mistress . . . Her husband is the melancholy man before us on the white horse, and his name is Oliver Cromwell.

He has not been long back from Parliament, and it will be ten or eleven years before he sits there again. In the meanwhile his notions about kingcraft have been sadly shaken, and he has made up his mind to devote himself to the interests of his family and of his grazing farm, and, above all, of his soul . . .

'Living neither in any considerable height nor yet in obscurity, I did endeavour', said he afterwards in a famous speech in Parliament, 'to discharge the duty of an honest man.'

Oliver Cromwell, as we see him here, is supposed by the artist to be returning from a neighbourly visit, and, on his homeward road, to have opened his Bible at these passages:

'Lord, how long? Wilt thou hide Thyself for ever?'

'And shall Thy wrath burn like fire?'

Pondering on the texts, he comes all at once on the burning stubble, and the concrete fact, so palpable to his outward eyes, answers readily to the vision within, and the man lapses, in the saddle where he sits, into a religious trance . . .[75]

The description provides a tremendous insight into the layers contained within the picture's subject-matter. Although its colouring is of the seventies, the design and execution are of the fifties and relate to Brown's Pre-Raphaelite days. He even returned to the habit of painting in the open air, working in the countryside around Morris's Kelmscott. The fact is that *Cromwell on his Farm* was first started in 1853, twenty years before, at exactly the same time that he began work on his better-known picture *The Last of England*. The theme of the former arose intially out of a deep personal depression which, in later life, Brown compared to the religious melancholy

he attempted to depict in his picture of Cromwell. He once wrote to a friend about this:

> I have suffered so much myself from imaginary nervousness, and every friend I have has suffered so exactly in the same way, that I cannot help thinking that I should be in some way helpful to you as a comparison.
>
> No man ever does any good in the world without passing through the phase some time between the ages of thirty and forty. This is what I endeavoured to depict in the *Cromwell on his Farm*, which seems so little understood by ordinary mortals.[76]

The picture is therefore both a personal and a public allegory of doubt, a crisis of faith. This surely is also reflected in its iconographical formula, with its direct echoes of a Conversion of St Paul. But why should Cromwell be Brown's chosen vehicle to present this dilemma of the present? The artist without doubt had an obsession with Cromwell. In 1878 he returned to him in *Cromwell discussing the Protection of the Vaudois with Milton and Andrew Marvell*, and he planned to execute several other pictures illustrative of Cromwell's career.[77] He even chose the name Oliver for his son, who died in the year in which *Cromwell on his Farm* was completed.

Our initial clue to this mania is the key figure in his canvas *Work*, also belonging to the early fifties – Thomas Carlyle, the historian, whose best-selling *Letters and Speeches of Oliver Cromwell* was published in 1845. These formulated the Victorian idea of the Lord Protector, which was a total reversal of that held by the previous century.[78] To the Enlightenment Cromwell had been, in the words of David Hume, 'a mixture of so much absurdity with so much penetration . . . tempering such violent ambition and such enraged fanaticism with so much regard to justice and humanity'.[79] This is the Cromwell whom West painted in 1783 in his *Oliver Cromwell ordering the Mace to be taken away*.

Scott's Cromwell in *Woodstock* (1826) takes us some way towards the Victorian cult figure:

> He was of middle stature, strong and coarsely made, with harsh and severe features . . . His manner of speaking . . . was energetic and forcible, though neither graceful not eloquent . . . It was also remarked of Cromwell, that though born of a good family . . . the fanatic democratic ruler could never acquire, or else disdained to practise, the courtesies usually exercised among the higher classes in their intercourse with each other. His demeanour was so blunt as sometimes might be termed clownish . . . [80]

Scott goes on to say, in line with his eighteenth-century predecessors, that no one would ever know where his religion ended and his hypocrisy began. Evangelical in religion, a self-made man, anti-aristocratic and anti-establishment by inclination, a reformer of passionate moral conviction, Cromwell had all the ingredients to make him the hero of the reformers, liberals and new men of nineteenth-century Britain.

The most important early collection of unbiased material on Cromwell to be published was Mark Noble's *Memoirs of the Protectoral House of Cromwell* (1784), but it was not until the 1830s and 1840s that the reappraisal of Cromwell became a major preoccupation of historians. During the forties Thomas Carlyle began to regard Cromwell as 'a great and true man' and 'one of the greatest souls ever born of English kin'. His famous edition of the *Letters and Speeches* billed Puritanism, to the reversal of Hume and the Enlightenment, as 'the last of our Heroisms',[81] and the Lord Protector was finally apotheosized, by the glory of Carlyle's passionate rhetoric, as a great national hero leading the country from darkness into light. No subsequent appraisal of Cromwell went untouched by Carlyle's impassioned partisanship.

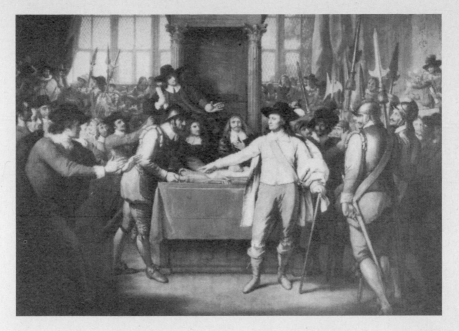

72. Benjamin West, *Oliver Cromwell ordering the Mace to be taken away* (1783).

In 1836 Daniel Maclise exhibited *An Interview between Charles I and Oliver Cromwell*, but it was not until after 1840, coinciding exactly with the new spate of literature, that Cromwell appeared with any degree of regularity as a permanent ingredient of Academy historical mythology. As such he was to continue until the 1870s.

The figure which emerges in these pictures is a very different one from the bigoted maniac of the eighteenth century. Augustus Egg painted Cromwell on the eve of the battle of Naseby (1859) like Christ undergoing the Agony in the Garden. Bathed in prophetic moonlight, the future Lord Protector is shown in a state of religious ecstasy. In 1863 Charles Lucy recreated the Cromwellian court, another aspect of the cult, portraying the Protector as the head of an ideal household, a pattern for middle-class behaviour of the present. Later, in 1867, David Wilkie Wynfield evoked the piety of Cromwell's death in a scene based on one of Carlyle's great set pieces, drawing this time on the iconography of the Death of the

Virgin. The Cromwell cult took on overtones of almost religious veneration as sacred iconography was automatically transferred to him.

The Victorian Cromwell was therefore a man of heroic stature.[82] Of Ford Madox Brown it was written that 'intellect made him a Socialist of an extreme type',[83] and with this as a lead it is hardly surprising to discover that the statue erected to Cromwell in Manchester (Mr Brockbank who commissioned *Cromwell on his Farm* was a Manchester man) was paid for by the wife of Abel Heywood, the city's leading radical publisher and an active Chartist.[84] Cromwell not only epitomized the self-made man, he expressed the idea of popular sovereignty and represented the exercise of power by someone of exemplary moral standards. Within a wider context, his achievements abroad in terms of foreign policy and maritime power foreshadowed the great age of the British Empire. (This is what Brown celebrates in *Cromwell discussing the Protection of the Vaudois*.) The relationship between his popularity among artists and his glorification by the exponents of radicalism cannot surely be a coincidence.

Cromwell emerged within the context of popular leadership with the rise of the Chartists, a working-class movement which sprang from the earlier failure of attempts at trade unionism and the frustrations evoked by the limitations of the 1832 Reform Bill. In 1838 the Chartists codified their demands for universal male suffrage, equal electoral districts, paid Members of Parliament, a secret ballot and annual Parliaments. After that year the campaign rose to a crescendo with mass demonstrations and torchlight processions. The movement was at its most dynamic through the forties until its ultimate failure in the year of revolutions, after which support fell away as control passed into the hands of extremists and Victorian England entered its economic heyday.

Throughout the 1840s Cromwell was held up as *the* great hero to the followers of Chartism, who overtly associated themselves in a

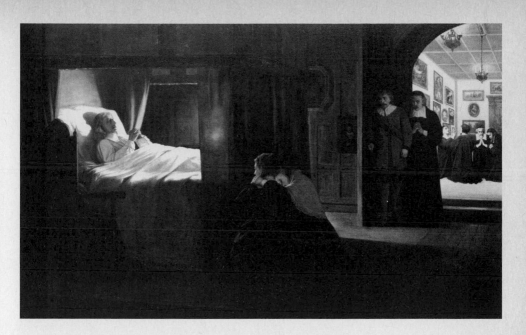

73. David Wilkie Wynfield, *The Death of Oliver Cromwell* (1867).

direct line of descent from the reforming groups of his time. Thomas Cooper lectured regularly on Cromwell in the Chartist interest up and down the country; so also did one of their greatest leaders and orators, Henry Vincent. Bearing all this in mind, one can see the significance of these images of Cromwell, and understand what could be read in England into Delaroche's *Cromwell gazing at the Body of Charles I* (1831), perhaps the most potent and gruesome of all the tableaux. Every history of the period accepts the unlikely account that Cromwell sat up with Charles I's coffin. Even S. R. Gardiner incorporates the story into his otherwise exemplary and precisely documented narrative of the Stuart period. The vivid account Merle d'Aubigné gives in his history captures the mingling of horror and destiny this composition was intended to evoke:

But there was a solemn lesson in his sovereign's lifeless corpse. He opened the coffin himself, and sadly gazed upon the cold inanimate body, without cruelty, or anger, or exultation, but

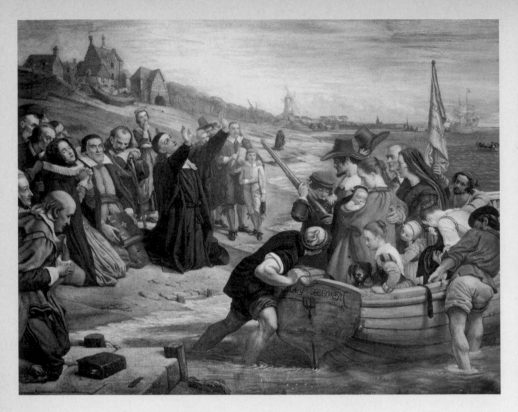

74. Charles West Cope, *The Embarking of the Pilgrim Fathers* (1856).

reverential fear, as he thought of the judgements of God . . .
And who was it that lay before him? . . . A descendant of kings,
– a mighty prince –, a ruler of three kingdoms . . . Cromwell
before the dead body of Charles I. is a scene worthy to be
described by a Milton, or a Shakespeare, or by some genius
still more sublime than even they.[85]

There is a footnote to the Cromwell cult in the Victorian age. As
the Lord Protector was rewritten into the part of a national saviour
of radical reform, the Puritans assumed a new role as the fore-
runners of middle-class morality. David Hume had spoken of the
Civil War as motivated by 'gloomy enthusiasm' which had
'poisoned' the body politic and led to 'puritanical absurdities'. The
Enlightenment naturally had no time for what it regarded as the

bigotry and downright hypocrisy of seventeenth-century evangelical movements. As, however, evangelical morality reasserted its sway over the upper and middle classes during the opening decades of the nineteenth century, the way was opened for a radical reassessment of Puritanism. Carlyle's conception of Cromwell greatly influenced the first favourable account, T. B. Marsden's *The History of the Early Puritans*, published in 1850. In 1856 the embarkation of the Pilgrim Fathers was depicted by C. W. Cope on the walls of the Houses of Parliament. The flag bears the motto 'Freedom of worship', and the placing of the Pilgrim Fathers as part of Victorian national mythology in the House reflects this total revolution in attitudes as vividly as does Brown's vision of Cromwell the prophet and seer.

SIX

The Victorian Image

'The loyal to their crown
Are loyal to their own far sons, who love
Our ocean-empire with her boundless homes
For ever-broadening England, and her throne
In our vast Orient, and one isle, one isle,
That knows not her own greatness . . .'
TENNYSON, 'To the Queen', *Idylls of the King*

I came to this book from my research on the Elizabethan age, and all the time I was writing it I was becoming more and more aware of the parallels between the two eras. And this in no false sense, but as providing a clue to a different way of looking at the art and culture of Victorian Britain. Perhaps an approach through the Elizabethan era could prove to be just as fruitful as the more conventional ones which regard the Victorian age either as our own century projected back to many of its seminal roots, or as the eighteenth century brought forward to a fulfilment.

The Elizabethan age and the Victorian were both intensely nationalistic, bent on creating mythologies powerful enough to hold together a divided people. The Elizabethans focused on their cult of the Virgin Queen, an ambiguous Virgin-Mother figure whose mystique and celebration in literature, festival and the visual arts bound together a kingdom rent asunder by religion. The nineteenth

century found in Victoria a Mother Empress who could above all be the pattern of the domestic virtues which sustained the ethics of behaviour for the whole of society, irrespective of class or religion. Kemble, the Anglo-Saxon historian, described her as 'fearless in the holy circle of her domestic happiness, secure in the affections of a people whose institutions have given to them all the blessings of an equal law'.[1] Both ages developed new national historical mythologies. The Elizabethan found its most vivid expression in the chronicles of Hall and Holinshed as transmuted by the play-wrights – the exaltation of the Tudor myth as a symbol of the nascent nationalism. The Victorian equivalent would range from Macaulay's *History of England* to Dickens's *A Child's History of England* (1851–3), and from whatever political stance it was viewed the saga was that of the evolution of Britain from feudal slavery to elected representative government.

In the Victorian age, as in the sixteenth century, there was an isolation from Europe and an expansion of empire. The stability of England, in comparison with the religious civil wars or endless revolutions prevalent elsewhere in these two periods, made this country the envy of the Continental mainland. Those who watched and hoped for a solution to the terrible division of Catholic and Protestant found in Elizabeth Tudor a symbol of hope to set against outright intolerance, against the extremes of Counter-Reformation thought with its stifling of intellectual speculation, against the hideous obscurantism and bloody persecution of Philip II's Spain. From the Low Countries, from Germany, from *politique* France, from tolerant Poland, from Italy and above all from Venice, all that was liberal in the stream of European humanist thought looked towards England. So, three hundred years later under Victoria, England was similarly looked to, this time for her liberal system of representative government, the model for those who aspired to over-throw the absolutist régimes re-established from the previous century. Whether in Byron's Greece, Garibaldi's Italy or the France

of 1830, 1848 or 1870, it was to Britain that the nationalistic liber-
ation movements looked, not only for refuge but for intellectual
support and as a focal point for their ideals. It is these themes of
ancient British liberties that are proclaimed again and again in the
stories and pictures of King Alfred, the death of Harold at the Battle
of Hastings, the signing of Magna Carta, the events of the Civil
War or the Glorious Revolution of 1688.

The imperial saga was equally rich for both Queens. The
Elizabethan period was the first heroic age of colonial endeavour
in the New World, but it was clothed with the sanctions of the
historic Tudor imperial myth, with the Queen as the descendant of
the ancient House of Troy now laying claim to an empire which,
if we are to believe some of the more extreme messianic prognos-
tications or the visual symbolism of her portraits, was to be global.
She was Spenser's most royall queen or empresse':

> Great lady of the greatest isle, whose light,
> Like Phoebus lamp throughout the world doth shine . . .[2]

Was Gloriana so very different from Tennyson's vision of Victoria
at her Jubilee?

> *Fifty times the rose has flower'd and faded,*
> *Fifty times the golden harvest fallen,*
> *Since our queen assumed the globe, the sceptre.*
>
> *She beloved for a kindliness*
> *Rare in fable or History,*
> *Queen and Empress of India,*
> *Crown'd so long with a diadem*
> *Never worn by a worthier . . .[3]*

Although the Victorian age rejected Elizabeth I because she
epitomized its female vices – spinsterhood, vanity and behaviour ill

befitting a lady – I cannot but believe that the celebration and cult of the Virgin Queen had a powerful influence on the cult of Victoria.

The theme of sea empire, to take one thread, can be traced down from Spenser's 'Cynthia, queen of seas and lands' to Tennyson's eulogy of Queen Alexandra as 'Bride of the heir of the Kings of the Sea'.[4] And it is to this tradition, of course, that G. F. Watts's *Alfred inciting the English to resist the Danes* belongs, as vividly as do the endless canvases of Nelson's victories. When it came to the imperial saga, even Oliver Cromwell could somehow be fitted in as a forerunner of imperial greatness.

So, too, both ages were obsessed by romance. In each case this was directly related to the papering over of vast social changes, in the sixteenth century the rise of the gentry and the establishment of a new post-Reformation aristocracy, in the nineteenth the advent of the new middle classes, particularly the urban industrialists. Both periods found in medieval romance and neo-Gothicism a façade with which to cover up this re-ordering of the social structure. For the Elizabethans it was manifested in their passion for tilts and tournaments, their love for romances of chivalry and the neo-Gothic style of their architecture. For the Victorians it was equally reflected in the transitory art of festival, whether in the form of the Eglinton Tournament or the masquerade balls given by Victoria, as well as in the literature pouring down from the Scott tradition and in the visual arts from Pugin to the Pre-Raphaelites. And, of course, all the pictures dealt with in this book are a direct reflection of this overwhelming ethos of romance. But it was romance tempered by new antiquarian standards. It is fascinating that not for a long time did the aim of accuracy in historical reconstruction become irreconcilable with a romantic view of the past. Indeed, it might be said to have strengthened it. As Jerome Hamilton Buckley has written: 'to . . . whatever use the past might be put, each historical reference was expected to rest upon a studious regard for fact and an ability to

enter, at least for one moment, imaginatively, even empathically into the life of another society'.[5]

As a consequence of their romantic ideals, both eras fostered a worship of the lady, bolstered and propagated in each case by the fact of the Queen regnant. The romantic cult of womanhood in the Elizabethan age combined the heroine of medieval romance with the Neoplatonized lady of Castiglione's *Courtier*. The women of the Victorian age were idolized as ideal wives and mothers, untouchable as were the consorts of medieval knights enshrined in their bowers. Their dream idealizations were the ladies of Tennyson or Burne-Jones, pale-faced, bewimpled and dressed in trailing robes. Winterhalter's Queen Victoria, wan in white, silhouetted in the twilight with a rose clasped to her bosom, is closer than a first glance would suggest to the Ermine Portrait of Elizabeth I. Encased in her ruff and studded with jewels, holding the olive branch of *pax*, Elizabeth is yet the heroine of her knights, and the little ermine of chastity alluding to this fact nestles on the sleeve of her dress. In each of the two Queens, therefore, the artificial chivalry of her age found its nodal point.

Elizabethan women of the upper classes, however, enjoyed a freedom and status unknown to the women of Victorian Britain. This representation may account for the overwhelming preoccupation in Victorian history paintings with womanhood and woman's proper role. Mary Queen of Scots and Lady Jane Grey, both tough, humanist-educated women holding their own in a man's world, are deliberately distorted to approximate to a view of women as inferior beings in a male-dominated society. *Pace* Victoria herself, their kingdom was the fireside and the nursery. Children also are distorted to fit into a romantic notion of the innocence of childhood. Whether we are looking at a medieval king and his brother or a little Cavalier boy in blue, they are not depicted as they would have been in their own ages – miniature adults – but as fragile beings uncorrupted as yet by the sin of adult life.

These pictures, which aimed at portraying the national past so vividly, are therefore key documents in unravelling what one might call 'the Victorian image'. Passionately patriotic, overtly romantic, they drew to themselves one further, even more potent thread from the make-up of the Victorian mind – that of religion. Just as the cult of the Virgin Elizabeth replaced in the minds of her subjects the cult of the Virgin Mary, so the celebration of the heroes and heroines of Great Britain's past had strongly religious overtones. Now, in a post-nationalistic age, we can see how the myths of nationalism were crucial for holding together the thought-assumptions of the teeming masses which made up the modern state. That they developed religious overtones is hardly surprising. Lady Jane Grey, Mary Queen of Scots, King Alfred, Harold, the Princes in the Tower, Charles I, Oliver Cromwell, even Bonnie Prince Charlie were all, in their varying ways, 'saints', and these pictures are celebrations of their virtues, their agonies and ecstasies and, often, their 'martyrdom'. This is reinforced by the artists' deliberate use in tackling these subjects of formulae derived from sacred iconography. Surely here we are touching the root of a vital part of the Victorian imagination.

These scenes from our national history have long lost their potency for us. It has been eroded by two world wars, by the collapse and dissolution of empire, by demands for devolution, by a revolution in the teaching of history both in universities and, even more, in schools. These pictures now remain as monuments to the lost era which strove so boldly to relive its own past. They speak to us of optimism and heroism, of pride in the past and tranquillity within the present in that second greatest of all our ages, the reign of Queen Victoria.

JWCI = Journal of the Warburg and Courtauld Institutes

Part One: The Century of History

1 A Victorian Vision

This unhelpful attitude to the study and appreciation of history painting in Britain is enshrined above all in E. K. Waterhouse, *Painting in Britain 1530 to 1790*, London, 1969 ed., pp. 187ff.: 'the idea took an intolerable time to die'.

2 History Writing and History Painting

1 On eighteenth-century historians and their attitude to the past see A. J. Grant, *English Historians*, London, 1906, pp. xxxi–xxxvi, 13–32; *The Evolution of British Historiography*, ed. J. R. Hale, Cleveland, N. Y., 1964, pp. 22–34, 142–66.

2 Henry St John, Viscount Bolingbroke, *Letters on the Study and Use of History*, London, 1752, p. 15.

3 M. Jourdain, *The Work of William Kent*, London, 1948; John Summerson, *Architecture in Britain 1530–1830*, London, 1963 ed., pp. 200–204, 237–9.

4 Oliver Millar, *The Tudor, Stuart and Early Georgian Pictures in the Collection of Her Majesty the Queen*, London, 1963, 1, pp. 27–8.

5 *Ibid.*, 1, pp. 171–2, nos 505–7.

6 *Ibid.*, 1, p. 50, nos 6 and 7.

7 Quoted Grose Evans, *Benjamin West and the Taste of his Times*, Illinois U.P., 1959, p. 31.

8 *Walpole Society*, XXVII, 1938–9, p. 74, no. 159.

9 John Sunderland, 'Mortimer, Pine and Some Political Aspects

of English History Painting', *Burlington Magazine*, CXVI, 1974, pp. 317–26.

10 Paul de Rapin-Thoyras, *Histoire d'Angleterre*, The Hague, 1724–36, IV, pp. 10–11.

11 The best account of Pine is in the *Dictionary of National Biography*.

12 For Mortimer see Benedict Nicolson, *John Hamilton Mortimer ARA, 1740–79*, Towner Art Gallery, Eastbourne and Iveagh Bequest, Kenwood, 1968.

13 *Walpole Society, op. cit.*, p. 73, no. 142.

14 Hume, *op. cit.*, I, pp. 160–61. He writes that 'the English themselves, by the accession of Edward, were delivered for ever from the dominion of foreigners' (p. 161). Sunderland (*op. cit.*, pp. 321–2) makes this a definitely anti-monarchical subject. As a subject it could be read more than one way.

15 Hume, *op. cit.*, II, p. 142.

16 A drawing for this is in the Vorarlberger Landesmuseum, Bregenz, rep. *Angelika Kauffmann und ihre Zeitgenossen*, Vorarlberger Landesmuseum, Bregenz and Österreichisches Museum für angewandte Kunst, Vienna, 1969, p. 76 (80a), pl. 232.

17 Rapin-Thoyras, *op. cit.*, I, pp. 96–111.

18 T. S. R. Boase, 'Macklin and Bowyer', *JWCI*, XXVI, pp. 170–74.

19 On Boydell see T. S. R. Boase, 'Illustrations of Shakespeare's Plays in the Seventeenth and Eighteenth Centuries', *JWCI*, X, 1947, pp. 94ff.; W. Moelwyn Merchant, *Shakespeare and the Artist*, London, 1959 (with an appendix giving locations of Boydell paintings as then known); Winifred H. Friedman, 'Some Commercial Aspects of the Boydell Shakespeare Gallery', *JWCI*, XXXVI, 1973, pp. 396–401; Hans Hammelman, *Book Illustrators in Eighteenth-Century England*, ed. T. S. R. Boase, Yale U.P., 1975, pp. 8–9; Winifred H. Friedman, *Boydell's Shakespeare Gallery*, Garland reprint, Harvard U.P., 1976, thesis.

20 For Bowyer see Boase, 'Macklin and Bowyer', *op. cit.*, pp. 174ff.

21 Mary Webster, *Francis Wheatley*, London, 1970, p. 147 (98), fig. 129; p. 178 (E 110).

22 David Irwin, *English Neoclassical Art*, London, 1966; and, more particularly, *Romantic Art in Britain, Paintings and Drawings 1760–1860*, Detroit Institute of Arts and Philadelphia Museum of Art, 1968.

23 Hume, *op. cit.*, III, p. 227.

24 Boase, 'Macklin and Bowyer', *op. cit.*, p. 177. Ada Earland, *John Opie and his Circle*, London, 1911, p. 335. Engraved W. Bromley, 1800.

25 David Irwin, 'Gavin Hamilton: Archaeologist, Painter and Dealer', *Art Bulletin*, XLIV, 1962, pp. 87–102.

26 Dora Wiebenson, 'Subjects from Homer's Iliad in Neoclassical Art', *Art Bulletin*, XLVI, 1964, pp. 29–30; *Romantic Art in Britain, op. cit.*, pp. 46–7, no. 11.

27 Frances A. Yates, *The Valois Tapestries*, London, 1959, p. 21, pl. 11(b).

28 Charles Mitchell, 'Benjamin West's "Death of General Wolfe" and the Popular History Piece', *JWCI*, VII, 1944, pp. 20–33.

29 John Galt, *The Life, Studies and Works of Benjamin West*, London, 1820, p. 48.

30 Allen Staley, 'The Landing of Agrippina at Brundisium with the Ashes of Germanicus', *Bulletin, Philadelphia Museum of Art*, LXI, no. 287–8, 1965–6, pp. 10–19; *Romantic Art in Britain, op. cit.*, pp. 98–9 (49).

31 The list of works in Galt, *op. cit.*, pp. 216–34 contains not only the many versions and sketches of several of the pictures but also other subjects from British history: King John and the barons with Magna Carta; the death of Sir Philip Sidney; the destruction of the Spanish Armada; the pardoning of John by his brother King Henry.

32 Henry Angelo, *Reminiscences*, London, 1904 ed., I, pp. 152–3.

33 Jules Prown, *John Singleton Copley, 1774–1815*, Washington D.C./Cambridge, Mass., 1966.

34 *Ibid.*, I, pp. 342ff.

35 *Ibid.*, II, p. 349 note 25, from the Assembly Minutes of the Royal Academy, II, pp. 77–8, 10 December 1779. Here Copley intercedes to save, from the old House of Lords building which was about to be demolished, some tapestries 'supposed to represent with uncommon truth and accuracy the costume, civil, religious and military, of the Country about the period of the fourteenth century; a Work of incalculable use to Artists . . .'.

36 On the historical novel see Avram Fleishman, *The English Historical Novel. Walter Scott to Virginia Woolf*, Johns Hopkins U.P., 1971, pp. 37ff.; George Lukács, *The Historical Novel*, London, 1969 ed., pp. 15ff.

37 Martin Kemp, 'Scott and Delacroix, with Some Assistance from Hugo and Bonington' in *Scott Bicentenary Essays*, ed. Alan Bell, Edinburgh, 1973, pp. 213–27.

38 Quoted by Hale, *op. cit.*, p. 36.

39 On which see Fleishman, *op. cit.*; J. C. Simmons, 'Of Kettledrums and Trumpets: The Early Victorian Followers of Scott', *Studies in Scottish Literature*, VI, 1965, pp. 47–59.

40 S. M. Ellis, *The Solitary Horseman or the Life and Adventures of G. P. R. James*, London, 1927.

41 Curtis Dahl, 'History on the Hustings: Bulwer-Lytton's Historical Novels of Politics' in *From Jane Austen to Joseph Conrad, Essays collected in Memory of James T. Hillhouse*, ed. Robert C. Rathburn and Martin Steinmann, Jr, University of Minnesota Press, 1958, pp. 60–71.

42 G. P. Gooch, *History and Historians in the Nineteenth Century*, London, 1913; Grant, *op. cit.*, pp. XXXIXff., 192ff.; Hale, *op. cit.*, pp. 39ff., 197ff.; Emery Neff, *The Poetry of History*, Cambridge U.P., 1967; Jerome Hamilton Buckley, *The Triumph of Time. A Study of the Victorian Concepts of Time, History, Progress, and Decadence*, Harvard U.P., 1967, especially chapter 11; *The Varieties of History, from Voltaire to the Present*, ed. Fritz Stern, 1972 ed., pp. 16–20; Olive Anderson, 'The Political Uses of History in mid-nineteenth-century England', *Past and Present*, 36, 1967, pp. 87–105.

43 Valerie E. Chancellor, *History for their Masters*, Bath, 1970.

44 John Lingard, *The History of England*, London, 5th ed., 1849, I, pp. xxvii–xxviii.

45 Peter Conrad, *The Victorian Treasure-House*, London, 1973, especially chapter 11.

46 This phenomenon needs greater research, particularly the interrelationship of literature, theatre and the visual arts. A study similar to the present one devoted to theatrical productions could be equally revealing.

47 George Craik and Charles MacFarlane, *The Pictorial History of England* (1837–44). The introduction states that it is 'enriched with appropriate woodcuts . . . copied from illuminated manuscripts of the period to which they belong . . . views of scenes . . . taken from prints or drawings as near the period as could be obtained . . . portraits and facsimiles . . . and, here and there, cuts from historical pictures' (the latter include Fuseli's *Caractacus*, Stothard's *Boadicea*, Tresham's *St Augustine preaching*, Smirke's *Canute rebuking the Courtiers*, etc.).

48 T. S. R. Boase, 'The Decoration of the New Palace of Westminster', *JWCI*, XVII, 1954, pp. 319–58.

49 Based on an analysis of the lists in Algernon Graves, *The Royal Academy of Arts*, London, 1905–6.

50 Andrew Shirley, *Bonington*, London, 1940; *R. P. Bonington, 1802–1828*, Castle Museum and Art Gallery, Nottingham, 1965 (ed. Marion Spencer).

51 Quoted by W. T. Whitley, *Art in England*, 1820–37, Cambridge, 1930, p. 147.

52 Robert Rosenblum, 'Painting under Napoleon, 1789–1799' in *French Painting 1774–1830: The Age of Revolution*, Grand Palais, Paris, Detroit Institute of Arts, Metropolitan Museum of Art, New York, 1975, pp. 168ff.

53 Robert Rosenblum, *Ingres*, London, 1967, pp. 12ff., and commentaries on pls 22, 26, 27 and 29.

54 Henri Delaborde and J. Goddé, *Oeuvre de Paul Delaroche*, Paris, 1858.

55 Whitley, *op. cit.*, p. 246. Scott, of course, knew Wilkie: Carola Oman, *The Wizard of the North. The Life of Sir Walter Scott*, London, 1973, p. 282.

56 C. R. Leslie, *Autobiographical Recollections*, ed. Tom Taylor, London, 1860, I, p. xxv; II, pp. 106, 111.

57 Martin Butlin and Evelyn Joll, *The Paintings of J. M. W. Turner*, Yale U.P., 1977, I, p. 173 (338).

58 Graham Reynolds, *Victorian Painting*, London, 1966, p. 111.

59 Robert Rosenblum, *Transformations in Late Eighteenth-Century Art*, Princeton U.P., 1967, and the same author's 'Painting under Napoleon, 1789–1799' and 'Painting During the Bourbon Restoration' in *French Painting 1774–1830: The Age of Revolution, op. cit.*, pp. 161–73, 231–44.

60 As quoted in *The Varieties of History*, ed. Fritz Stern, New York, 1973 ed., p. 15.

3 The Re-creation of the Past

1 The following account is based on Joan Evans, *A History of the Society of Antiquaries*, Oxford, 1956.

2 Horace Walpole to Cole, September 1778, quoted *ibid.*, p. 155.

3 *Ibid.*, p. 42.

4 Robert Raines and Kenneth Sharpe, 'The Story of King Charles I: Part I', *Connoisseur*, CLXXXIV, 1973, p. 46.

5　Reynolds to Lord Hardwick, concerning a proposal for a picture on the subject of the interview between James II and the Duke of Monmouth, 5 March 1783, quoted in Frederick W. Hilles, *The Literary Career of Sir Joshua Reynolds*, Cambridge, 1936, pp. 101–2.

6　In Henry Hallam's *The Principles which may regulate the selection of subjects for painting in the Palace of Westminster* it was stipulated that the subjects should reveal the human form 'to a considerable extent uncovered', with the result that the 1843 competition subject-matter never passed the Plantagenet period. 'If,' Hallam wrote, '[an artist] is compelled to exhibit modern dress, the naked form is entirely hid, and the drapery is already disposed by the tailor' (*Parliamentary Papers*, 1844, XXI, p. 189).

7　On Strutt see *Dictionary of National Biography* and the introduction to the 1903 edition of his *Sports and Pastimes of the People of England*.

8　Joseph Strutt, *The Regal and Ecclesiastical Antiquities of England . . .*, London, 1773, title-page.

9　*Ibid.*, p. 26 and note.

10　*Ibid.*, p. iii.

11　Joseph Strutt, *A Complete View of the Dress and Habits of the People of England*, ed. J. R. Planché, London, 1842, I, p. vii.

12　J. R. Planché, *History of British Costume*, The Library of Entertaining Knowledge, London, 1834, p. xii.

13　*Ibid.*, p. xi.

14　*Ibid.*, p. 198, compiled from Strutt, *Dress and Habits, op. cit.*, II, pls CXVIII, CXIX. Other figures lifted and adapted from the same source are p. 116 from pl. XCVIII (redrawn and with a head reversed); p. 132 from pl. XCVI; p. 188 from pl. XCIII; p. 201 from pl. CXXVII; p. 206 from pls CXXII, CXXIII; p. 218 from pl. CXXIV (reversed); p. 220 from pl. CXXXVIII; p. 230 from pl. CXXXV; and from *Regal and Ecclesiastical Antiquities*, p. 190 from pl. XLIII; p. 199 from pl. XLVII.

15　F. W. Fairholt, *Costume in England. A History of Dress from the Earliest Period until the Close of the Eighteenth Century*, London, 1860 ed., preface.

16　The following are from *Dress and Habits*: p. 161 from II, pl. CXXXII; p. 142 from pl. LXXVI and pl. XCIII with one figure reversed; p. 183 from pls CXXXII, CXXVIII; p. 136 from pl. XCIV; p. 89 from pl. LXII; and from *Regal and Ecclesiastical Antiquities*, p. 168 from pl. XXXIII; p. 110 from pl. XIX.

17　Fairholt, *op. cit.*, p. 142.

18 Alfred John Kempe, *Introduction and Descriptions for Stothard's Monumental Effigies of Great Britain*, 1832.

19 Francis Grose, *A Treatise on Ancient Armour and Weapons . . .*, London, 1786, sig. A2.

20 Samuel Rush Meyrick and Charles Hamilton Smith, *The Costume of the Original Inhabitants of the British Islands, from the earliest periods in the sixth century*, London, 1815.

21 Samuel Rush Meyrick, *A Critical Inquiry into Antient Armour, as it existed in Europe, but particularly in England, from the Norman Conquest to the Reign of King Charles II*, London, 1842, ed., preface, pp. x, xii–xiii. Meyrick, of course, denounces Grose's work.

22 *Ibid., loc. cit.*, where he expresses gratitude to Scott for information on Scottish armour and refers to him as 'his good friend'.

23 Roger Smith, 'Bonnard's *Costume Historique* – a Pre-Raphaelite Source Book', *Costume*, VII, 1973, pp. 28–37.

24 Leonée Ormond, 'Dress in the Painting of Dante Gabriel Rossetti', *Costume*, VIII, 1974, pp. 26–9.

25 W. M. Thackeray, *Critical Papers in Art, Stubbs' Calendar, Barber Cox*, London, 1904, p. 121.

26 *Ibid., loc. cit.*

27 *Ibid.*, p. 221.

28 J. R. Planché, *Recollections and Reflections*, London, 1872, I, pp. 225–6.

29 *Ibid.*, I, pp. 228–9.

30 *Ibid.*, I, p. 229.

31 *Ibid.*, I, p. 231.

32 *Ibid.*, I, pp. 332–3.

33 Many artists were dabbling with amateur theatricals, e.g. Frith, Millais and E. M. Ward designing costumes for them, as recorded in Mrs E. M. Ward, *Memories of Ninety Years*, ed. Isabel McAllister, n.d., p. 49. See p. 42 for Wilkie arranging historical tableaux from Scott's novels.

34 Evans, *op. cit.*, pp. 62–3.

35 *Ibid.*, p. 64.

36 *Art Journal*, XII, 1850, p. 68.

37 As quoted in Edmund Lodge, *Portraits of Illustrious Personages of Great Britain*, Bohn Edition, London, 1849–50, I, p. vii.

38 Richard and Samuel Redgrave, *A Century of British Painters*, London,

1947 ed., p. 339: 'he was able to dispose loose drapery on his model
. . . as to enable him to represent his costume without the aid of the
milliner'.

39 Information kindly communicated by Mr Richard Ormond.

40 *Specimens of Ancient Furniture drawn from existing authorities by Henry Shaw
F.S.A.; with descriptions by Sir Samuel Rush Meyrick K.H.*, London, 1836,
prospectus.

41 *Daniel Maclise, 1806–1870*, Arts Council Exhibition, National Portrait
Gallery, London and National Gallery of Ireland, Dublin, 1972 (cata-
logue and introduction by Richard Ormond), p. 95 (100).

42 C. K. Adams and W. S. Lewis, 'The Portraits of Horace Walpole',
Walpole Society, XLII, 1970, p. 25 (B7).

43 Joseph Nash, *The Mansions of England in the Olden Time*, ed.
J. Corbet Anderson, 1869–72, II, quoting Nash: 'I have carefully
abstained from introducing any subject that is not a genuine speci-
men of the style peculiar to its age . . . The figures introduced, both
as regards their costumes and occupations, are all from authority;
and the object of their introduction has been not merely an eye to
pictorial effect, but a desire to identify the characters and habits of a
people that have now passed away, and to represent, in its various
peculiarities, the very age and body of the time.'

44 See *Dictionary of National Biography*, s.v. Cattermole.

45 Dated 1 March 1851; quoted by Ford H. Hueffer, *Ford Madox Brown:
A Record of His Life and Work*, London, 1896, I, p. 72. Kindly commu-
nicated by Mr Richard Ormond.

46 Quoted in *Romantic Art in Britain, Paintings and Drawings 1760–1860*,
Detroit Institute of Arts and Philadelphia Museum of Art, 1968, p.
297.

47 Letter to J. Comyns Carr, 1873, quoted by Richard and Leonée
Ormond, *Lord Leighton*, Yale U.P., 1973, p. 85.

4 Decline and Eclipse

1 G. A. Storey, *Sketches from Memory*, London, 1899, p. 250.

2 *Ibid., loc. cit.*

3 As quoted in *The Varieties of History*, ed. Fritz Stern, New York, 1973
ed., p. 15.

Part Two: Themes and Obsessions

5 Reliving the Past

1 M. H. Spielman, *The Work of G. F. Watts*, Pall Mall Gazette Extra, 1886; H. Macmillan, *The Life and Work of George Frederick Watts, R.A.*, London, 1903; M. S. Watts, *George Frederick Watts*, London, 1912; see *G. F. Watts. A Nineteenth-Century Phenomenon*, Whitechapel Art Gallery, London, 1974 (chosen by John Gage, introduction by Chris Muller), appendix 1 for bibliography.

2 Watts, *op. cit.*, 1, pp. 76ff.

3 John Lingard, *The History of England*, London, 5th ed., 1849, 1, p. xiv.

4 David Hume, *The History of England*, Edinburgh, 1818 ed., 1, pp. 76ff.

5 For Bowyer's Historic Gallery: Mary Webster, *Francis Wheatley*, London, 1970, p. 147 (98).

6 *Paintings and Drawings by Sir David Wilkie, R. A., 1785–1841*, National Gallery of Scotland, Edinburgh and Royal Academy, London, 1958 (catalogue and introduction by John Woodward), p. 23 (29).

7 Avram Fleishman, *The English Historical Novel. Walter Scott to Virginia Woolf*, Johns Hopkins U.P., 1971, pp. 56–7.

8 In *Ivanhoe*, Scott type-cast them thus: 'It seemed to the author that the existence of the two races in the same country, the vanquished distinguished by their plain, homely, blunt manners, and the free spirit infused by their ancient institutions and laws; the victors, by the high spirit of military fame, personal adventure, and whatever could distinguish them as the Flower of Chivalry, might, intermixed with other characters belonging to the same time and country, interest the reader by the contrast, if the author should not fail on his part' (*The Waverley Novels*, Edinburgh, 1879 ed., XVI, *Ivanhoe*, 1, p. 5). See also Christopher Hill, 'The Norman Yoke' in *Democracy and Labour: Essays in Honour of Donna Torr*, ed. John Saville, 1954, pp. 11–66.

9 Quoted by Derek Beales, *From Castlereagh to Gladstone*, New York, 1969, p. 58.

10 Olive Anderson, 'The Political Uses of History in mid-nineteenth-century England', *Past and Present*, 36, 1967, pp. 87–105.

11 J. M. Kemble, *The Saxons in England*, London, 1849, 1, pp. V–VI.

12 *Centenary Exhibition of the Work of William Dyce, R.A. (1806–1864)*,

Aberdeen Art Gallery and Thomas Agnew & Sons, London, 1964 (catalogue and introduction by Charles Carter).

13 *The Late Richard Dadd 1817–1886*, Arts Council Exhibition, Tate Gallery, etc., 1974–5 (catalogue and introduction by Patricia Alldderidge), p. 54 (40).

14 R. J. B. Walker, *A Catalogue of paintings, drawings, sculpture and engravings in the Palace of Westminster*, 1962 (typescript), part IV, pp. 28–9.

15 *Millais*, Walker Art Gallery, Liverpool and Royal Academy, London, 1967 (catalogue and introduction by Mary Bennett), p. 22 (6).

16 Kenneth Romney Towndrow, *The Works of Alfred Stevens in the Tate Gallery*, London, 1950, p. 67 (72) and related studies (nos 73–9).

17 *Daniel Maclise, 1806–1870*, Arts Council Exhibition, National Portrait Gallery, London and National Gallery of Ireland, Dublin, 1972 (catalogue and introduction by Richard Ormond), pp. 97–8 (102).

18 Walker, *op. cit.*, part IV, p. 75. See also the entry by Allen Staley on Ford Madox Brown's *The Body of Harold brought before William the Conqueror (Wilhelmus Conquistador)* (1844–61, Manchester City Art Gallery) in *Romantic Art in Britain, Paintings and Drawings 1760–1860*, Detroit Institute of Arts and Philadelphia Museum of Art, 1968, pp. 296–8 (210).

19 M. H. Spielman, *Millais and His Works*, Edinburgh and London, 1898; John Guille Millais, *The Life and Letters of Sir John Everett Millais*, London, 1899; Mary Lutyens, *Millais and the Ruskins*, London, 1967; *Millais*, Walker Art Gallery, Liverpool and Royal Academy, London, 1967 (catalogue and introduction by Mary Bennett).

20 Spielman, *op. cit.*, p. 134 (150); Millais, *op. cit.*, II, pp. 88, 91, 102; Bennett, *op. cit.*, p. 55 (93).

21 On the historiography of the murder of the Princes in the Tower see Paul Murray Kendall, *Richard III*, London, 1955, pp. 393ff.; *Richard III*, National Portrait Gallery, London, 1973 (catalogue by Pamela Tudor-Craig), pp. 51–4.

22 David Hume, *The History of England*, Edinburgh, 1818 ed., III, pp. 271–2.

23 Winifred H. Friedman, *Boydell's Shakespeare Gallery*, Garland reprint, Harvard U.P., 1976, pp. 164–5, 230–31.

24 Hume, *op. cit.*, III, p. 280.

25 T. S. R. Boase, 'Macklin and Bowyer', *JWCI*, XXVI, 1963, p. 177.

26 Friedman, *op. cit., loc. cit.*

27 On which see *French Painting 1774–1830: The Age of Revolution*, Grand Palais, Paris, Detroit Institute of Arts, Metropolitan Museum of Art, New York, 1975, pp. 389–90 (44) and bibliography. Replica in the Wallace Collection, London.

28 See Cecil Gould, *Delaroche and Gautier. Gautier's Views on the Execution of Lady Jane Grey and on other compositions by Paul Delaroche*, National Gallery, London, 1975.

29 See the most recent biography, Hester W. Chapman, *Lady Jane Grey*, London, 1962, pp. 204ff.

30 For a short account of later attitudes see *ibid.*, pp. 173–4.

31 Gilbert Burnet, *The History of the Reformation of the Church of England*, Oxford, 1829, II, pp. 469–70.

32 T. S. R. Boase, 'Macklin and Bowyer', *JWCI*, XXVI, 1963, p. 177.

33 Jules Prown, *John Singleton Copley, 1774–1815*, Washington D.C./ Cambridge, Mass., 1966, II, p. 376.

34 George Scharf, *A Descriptive and Historical Catalogue of the Collection of Pictures at Woburn Abbey*, 1890, pp. 247–8; C. R. Leslie, *Autobiographical Recollections*, ed. Tom Taylor, London, 1860, II, pp. 181–2.

35 See list, p. 161.

36 See p. 173, note 17 for bibliography on Victorian concepts of womanhood.

37 Maria, Lady Callcott, *Little Arthur's History of England*, London, 1955 ed., pp. 163–4. Original edition 1835.

38 Agnes Strickland, *Lives of the Tudor Princesses*, London, 1868, p. 94.

39 *Catalogue of Paintings and Sculpture*, National Gallery of Scotland, Edinburgh, 1957 ed., p. 15 (1677).

40 The best account of Allan is that in the *Dictionary of National Biography*.

41 See Antonia Fraser, *Mary Queen of Scots*, London, 1969, pp. 250ff., for the most recent account of the celebrated murder.

42 James Emerson Phillips, *Images of a Queen. Mary Stuart in Sixteenth-Century Literature*, University of California Press, 1964.

43 Antonia Fraser, 'Mary Queen of Scots and the Historians', *Royal Stuart Society Papers*, VII, 1974.

44 See p. xx. The picture was engraved by Francis Legat and published by Boydell. Dr Johnson provided the inscription beneath: 'Mary, Queen of Scots, harassed, terrified and overpowered by insults, menaces and clamours of her rebellious subjects, sets her hand, with

tears and confusion, to a resignation of the kingdom' (J. T. Smith, *Nollekens and His Times*, London, 1829, II, pp. 284–5).

45 John Jope Rogers, *Opie and His Works*, London, 1878, pp. 191–3; Ada Earland, *John Opie and His Circle*, London, 1911, pp. 333–4.

46 On Scott and Mary see Avram Fleishman, *The English Historical Novel. Walter Scott to Virginia Woolf*, Johns Hopkins U.P., 1971, pp. 61–2.

47 George Chalmers, *The Life of Mary, Queen of Scots*, London, 1822, I, preface.

48 Carola Oman, *The Wizard of the North. The Life of Sir Walter Scott*, London, 1973, p. 256.

49 *The Waverley Novels*, Edinburgh, 1895 ed., xxi, *The Monastery*, pp. 5–6. Scott actually did not privately subscribe to the cult of the Queen, and refused to write a biography of her: 'and that I decidedly would not do, because my opinion, in point of fact, is contrary both to the popular feeling and my own' (Oman, *op. cit.*, p. 333).

50 See list, pp. 162–3.

51 *Paintings and Drawings by Sir David Wilkie, R.A., 1785–1841*, National Gallery of Scotland and Royal Academy, 1958 (catalogue and introduction by John Woodward), p. 46 (105).

52 *Ibid.*, p. 43 (90–91).

53 W. P. Frith, *My Autobiography and Reminiscences*, London, 1887, I, p. 110.

54 *Ford Madox Brown, 1821–1893*, Walker Art Gallery, Liverpool, etc., 1964–5 (catalogue with introduction by Mary Bennett), p. 11. (3). The finished picture is lost.

55 This account of the Victorian concepts of the lady and of womanhood is based on: Robert Palfrey Utter and Gwendolyn Bridges Needham, *Pamela's Daughters*, London, 1937; Patricia Thomson, *The Victorian Heroine. A Changing Ideal*, London, 1956; Kate Millett, 'The Debate over Women: Ruskin versus Mill', *Victorian Studies*, XIV, 1970, pp. 63–71; *Suffer and Be Still. Women in the Victorian Age*, ed. Martha Vicinus, Indiana U.P., 1973.

56 Agnes Strickland, *Lives of the Queens of Scotland &c.*, Edinburgh and London, 1852, III, p. 223.

57 M. H. Stephen-Smith, *Art and Anecdotes: Recollections of William Yeames*, London, 1927.

58 *Ibid.*, pp. 171–4.

59 See pp. 32–3.

60 David Hume, *The History of England*, Edinburgh, 1818 ed., VI, p. 465.

61 See *The History of Great Britain. The Reigns of James I and Charles I*, ed. Duncan Forbes, Harmondsworth, 1970, introduction.

62 Hume, *op. cit.*, VI, pp. 468–9.

63 On Scott and the Cavaliers see Avram Fleishman, *The English Historical Novel. Walter Scott to Virginia Woolf*, Johns Hopkins U.P., 1971, pp. 64ff.

64 *The Waverley Novels*, Edinburgh, 1879 ed., XXXIX, *Woodstock*, II, pp. 83–4.

65 *Daniel Maclise, 1806–1870*, Arts Council Exhibition, National Portrait Gallery, London and National Gallery of Ireland, Dublin, 1972 (catalogue and introduction by Richard Ormond), pp. 62–3 (68).

66 Roy Strong, *Van Dyck. Charles I on Horseback*, London, 1972, pp. 36ff.

67 F. Guizot, *History of the English Revolution of 1640*, transl. William Hazlitt, London, 1845, pp. xvi–xvii.

68 See R. J. B. Walker, *A Catalogue of paintings, drawings, sculpture and engravings in the Palace of Westminster*, 1962 (typescript), part IV, pp. 17ff., appendix IV, p. 167.

69 Henry Hallam, *The Constitutional History of England*, London, Everyman ed., 1913, II, p. 126.

70 Henry Hallam, *View of the State of Europe during the Middle Ages*, London, 1878 ed., II, p. 269.

71 *Victorian Engravings*, Victoria & Albert Museum, London, 1973 (catalogue and introduction by Hilary Beck), p. 65 (45).

72 Stephen-Smith, *op. cit.*, pp. 173–4.

73 Ford H. Hueffer, *Ford Madox Brown: A Record of his Life and Work*, London, 1896; *Ford Madox Brown, 1821–1893*, Walker Art Gallery, Liverpool, etc., 1964–5 (catalogue with introduction by Mary Bennett).

74 Bennett, *op. cit.*, p. 26 (42); *Catalogue of the Lady Lever Gallery, Port Sunlight*, 1928, p. 87 (21).

75 Hueffer, *op. cit.*, pp. 290–92.

76 *Ibid.*, p. 315.

77 *Ibid.*, p. 311.

78 On the historiography of Oliver Cromwell see Wilbur Cortez Abbott, 'The Fame of Oliver Cromwell' in *Conflicts with Oblivion*, London, 1935, pp. 151–80; Maurice Ashley, *The Greatness of Oliver Cromwell*, London,

1957, pp. 12–22; *Great Lives Observed, Cromwell,* ed. Maurice Ashley, Englewood Cliffs, N. J., 1969.

79 Ashley, *Great Lives, op. cit.,* p. 127.

80 *The Waverley Novels,* Edinburgh, 1879 ed., xxxix, *Woodstock,* 1, pp. 202–4.

81 Thomas Carlyle, *Oliver Cromwell's Letters and Speeches,* London, 1887 ed., 1, p. 4.

82 See T. W. Mason, 'Nineteenth-Century Cromwell', *Past and Present,* 40, 1968, pp. 187–9; J. P. D. Dunbabin, 'Oliver Cromwell's Popular Image in Nineteenth-Century England' in *Britain and the Netherlands,* eds J. S. Bromley and E. H. Kossman, v, The Hague, 1976, pp. 140–63.

83 Hueffer, *op. cit.,* p. 401.

84 W. J. Linton, *Memories,* London, 1895, p. 29.

85 J. H. Merle d'Aubigné, *The Protector: A Vindication,* Edinburgh, 1847, p. 134.

6 The Victorian Image

1 J. M. Kemble, *The Saxons in England,* London, 1849, 1, p. v.

2 Spenser, *Faerie Queene,* 1, introduction, iv.

3 Tennyson, 'On the Jubilee of Queen Victoria'.

4 Tennyson, 'A Welcome to Alexandra'.

5 Jerome Hamilton Buckley, *The Triumph of Time. A Study of the Victorian Concepts of Time, History, Progress, and Decadence,* Harvard U.P., 1967, p. 16.

1. Sir John Everett Millais, *The Boyhood of Raleigh* (Tate Gallery, London).
2. George Vertue, imaginary scene of the abdication of Richard II. Detail of engraving from Paul de Rapin-Thoyras, *The History of England* (photo: National Portrait Gallery).
3. William Kent, *The Battle of Agincourt* (Royal Collection).
4. William Kent, *The Meeting between Henry V and the Queen of France* (Royal Collection).
5. Henry V by unknown artist (Royal Collection).
6. Robert Edge Pine, *Earl Warren making Reply to the Writ commonly called 'Quo Warranto' in the Reign of Edward I, 1278* (National Trust, Sudbury).
7. John Hamilton Mortimer, *Vortigern and Rowena*.
8. John Francis Rigaud, *Lady Elizabeth Grey petitioning King Edward IV for her Husband's Lands* (photo: National Portrait Gallery, London).
9. John Downman, *Edward IV on a Visit to the Duchess of Bedford, is enamoured of Lady Elizabeth Grey* (photo: National Portrait Gallery, London).
10. After John Opie, *Lady Elizabeth Grey entreating Edward IV to protect her Children* (Courtauld Institute of Art).
11. Gavin Hamilton, *Mary Queen of Scots resigning her Crown* (University of Glasgow).
12. Engraving by R. Sheppard of a miniature thought to represent Mary Queen of Scots.
13. Benjamin West, *Edward III and the Burghers of Calais* (Royal Collection).
14. John Hall after Edward Edwards, *The Surrender of Calais to Edward III* (photo: National Portrait Gallery, London).
15. Benjamin West, *Queen Elizabeth going in Procession to St Paul's Cathedral after the Destruction of the Spanish Armada* (photo: National Portrait Gallery, London).
16. John Singleton Copley, *Charles I demanding in the House of Commons the Five Impeached Members* (Public Library, Boston, Mass.).
17. Richard Parkes Bonington, *Henry III and the English Ambassador* (Wallace Collection, London).

40. *Henry Howard, Earl of Surrey*, engraving by Edward Scriven.

41. Richard Parkes Bonnington, *The Earl of Surrey and the Fair Geraldine* (Wallace Collection, London).

42. Augustus Leopold Egg, *Queen Elizabeth discovers she is no longer Young*.

43. Detail from William Larkin's portrait of Anne Clifford, Countess of Dorset (Lord Sackville, Knole).

44. Ford Madox Brown, *John Wycliffe reading his Translation of the Bible to John of Gaunt* (Bradford Art Galleries and Museum).

45. Canopied chair from Henry Shaw, *Specimens of Ancient Furniture drawn from existing authorities*.

46. Reading desk from Shaw, *Specimens of Ancient Furniture*.

47. John Carter, *The Entry of Prince Frederick into the Castle of Otranto* (W. S. Lewis, Farmington, Connecticut).

48. The Hall at Penshurst, Kent, from Joseph Nash, *The Mansions of England in the Olden Time*.

49. 'Ladies of the Rank of the 15th and 16th Centuries', from Strutt, *The Dress and Habits*.

50. The Gallery at Hatfield House, from Joseph Nash, *The Mansions of England in the Olden Time*.

51. Anne of Denmark, from Strutt, *The Dress and Habits*.

52. Marcus Gheeraerts, *Anne Pope, Lady Wentworth, later Countess of Downe, and her Children*.

53. George Cattermole, *Goring Carousing* from *The Great Civil War of Charles I and the Parliament*.

54. G. F. Watts, *Alfred inciting the English to resist the Danes* (Houses of Parliament).

55. John Francis Rigaud, *The first Interview of King Edgar and Elfrida* (National Trust, Saltram).

56. Alfred Stevens, *King Alfred and his Mother* (Tate Gallery, London).

57. Frederick Richard Pickersgill, *The Burial of Harold* (Houses of Parliament).

58. Sir John Everett Millais, *The Princes in the Tower* (Royal Holloway College, University of London).

59. Paul Delaroche, *Edward V and the Duke of York in the Tower* (Wallace Collection, London).

60. Paul Delaroche, *The Execution of Lady Jane Grey* (National Gallery, London).

61. C. R. Leslie's *Lady Jane Grey prevailed upon to accept the Crown* (Woburn